FASHION ILLUSTRATION

Inspiration and Technique

ANNA KIPER

D&C
David and Charles

To my family

A DAVID & CHARLES BOOK
Copyright © David & Charles Limited 2011

David & Charles is an F+W Media, Inc. company
4700 East Galbraith Road
Cincinnati, OH 45236

First published in the UK in 2011
Copyright © Anna Kiper 2011

A catalogue record for this book is
available from the British Library.

ISBN-13: 978-0-7153-3618-2
ISBN-10: 0-7153-3618-5

Printed in China by RR Donnelley
for David & Charles
Brunel House, Newton Abbot, Devon

Senior Acquisitions Editor: Freya Dangerfield

David & Charles publish high quality books
on a wide range of subjects.
For more great book ideas visit:
www.rubooks.co.uk

B

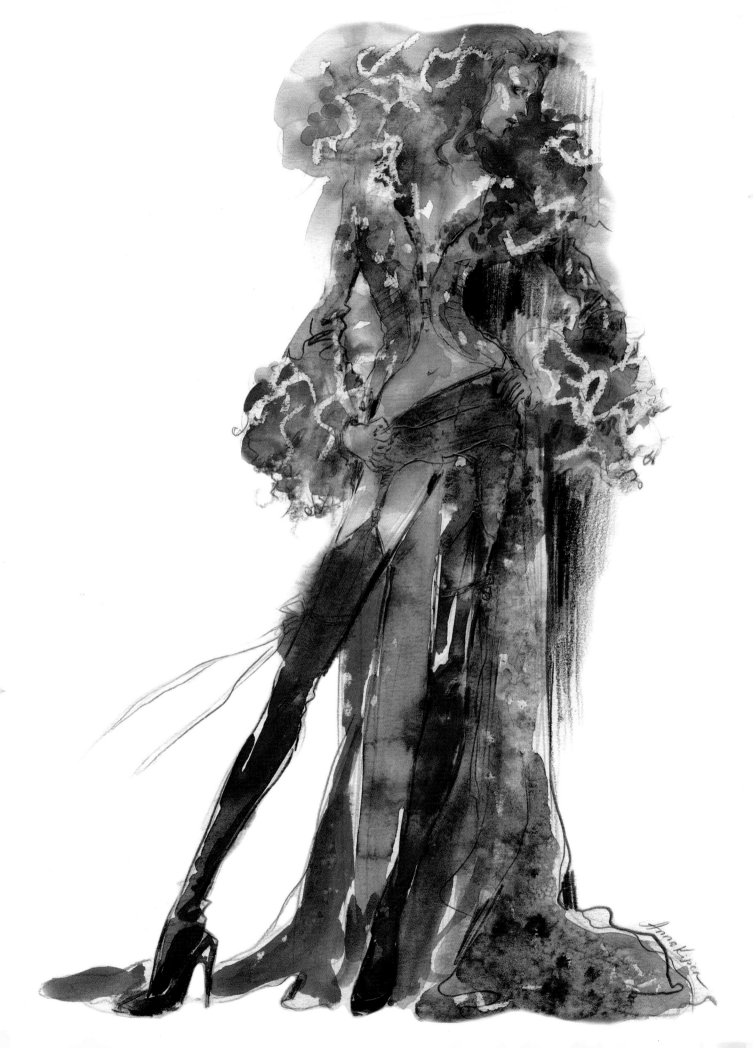

CONTENTS

INTRODUCTION

It's a miracle that my interest in fashion took root in Cold War Russia—a land untouched by Western fashion trends and full of grey uniforms, emotional restraint, and hostility toward creative expression and individuality. My only escape from the grim reality of my childhood was reading fairytales and marvelling at the intricacies of the traditional Russian costume illustrations of the famous Bilibin.

In my teenage years, I was opened up to a whole new artistic world when I discovered the magical watercolours of Leon Bakst and Alexandre Benois. The decadence of early 20th century Russia and its influence on art and literature fueled my imagination and creativity. Artists like Vrubel and Roerich, and the poetic genius of Gumilev and Blok influenced my vision, molded my artistic sense, and inspired me to pursue a career in art and fashion. Despite the hardships of immigrating alone to the United States as a young girl and the obstacle of overcoming cultural differences, my interest and commitment to fashion continued to grow.

Throughout history, costumes have often been illustrated by artists with great attention to detail, but it was only through the posters of Toulouse-Lautrec and the ink drawings of Aubrey Beardsley and Erté in the late 19th and early 20th centuries, that fashion illustration emerged into an art form. The 30s and 40s saw a glamorous style of fashion illustrated in the work of René Bouët-Willaumez, Carl Erickson, and René Gruau in the 50s. In the 70s and 80s, fashion illustration had a huge impact on fashion design, and the influence of urban street trends on fashion culture was noticeable everywhere. This was evident in the electric brilliance of Antonio Lopez, the New Wave energy of Tony Viramontes, and the bold simplicity of Mats Gustavson.

In the 90s, fashion photography overshadowed illustration—a side effect of the technological revolution. As computers continued to simplify the world and as digital art became popular, the demand for hand-drawn art began to diminish. The studios of Steven Meisel, Sarah Moon, and Tim Walker produced beautiful photography. However, even the most compelling photographs could not replicate the magic of the artist's hand and the unique relationship that is created between the artist, the artwork, and the viewer. A hand drawing creates a direct connection to the artist, expressing the individual style, energy and creativity.

Drawing is vitally important for the fashion industry. Many top designers, such as Karl Lagerfeld, Christian Lacroix, and Yves Saint Laurent, have freely expressed their ideas by illustrating their own designs on paper as a preliminary step in creating their collections.

This book represents a designer's point of view on fashion illustration and will hopefully contribute to the revival of this unique art form. Every illustration lesson in the book presents a story with exciting design details and ideas, which I hope will inspire more designers to rediscover the art of hand drawing as a tool for creating vibrant and original work.

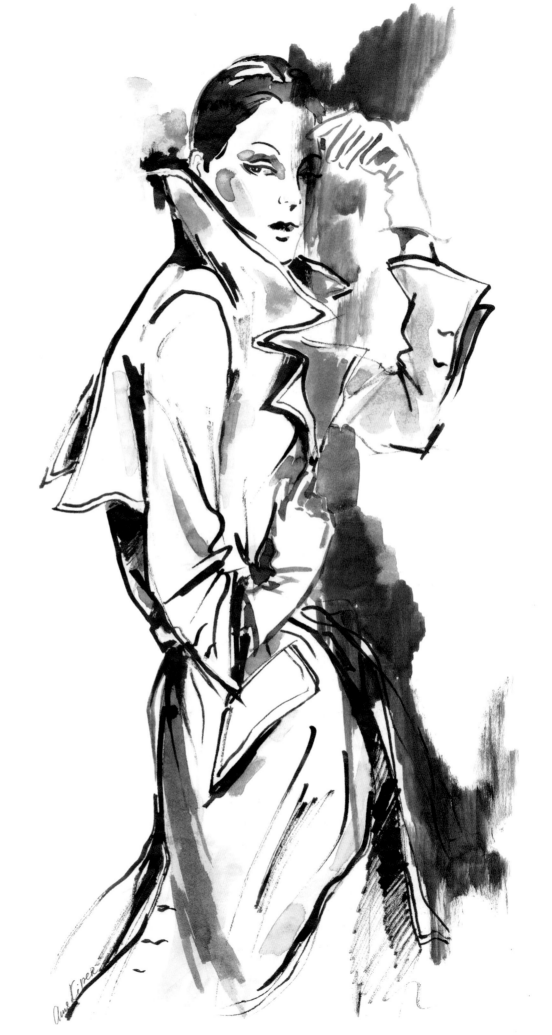

THE FASHION FIGURE

FREEHAND GESTURE

Freehand gesture drawing is a quick, loose, and spontaneous sketching technique. The proportions are indicated intuitively and emphasize personal style.

10-HEAD PROPORTIONS

Head length is often used as a measuring tool when drawing the fashion figure.

The 10-head figure proportion is ideal for stylized fashion croquis. This is an elongated version of the realistic 8-head human proportion.

The images on the opposite page represent a map of the fashion figure's proportions. It is important to remember that all the measurements are approximate and can vary from artist to artist.

10-HEAD BASIC CROQUIS

BASIC CROQUIS IN ACTION

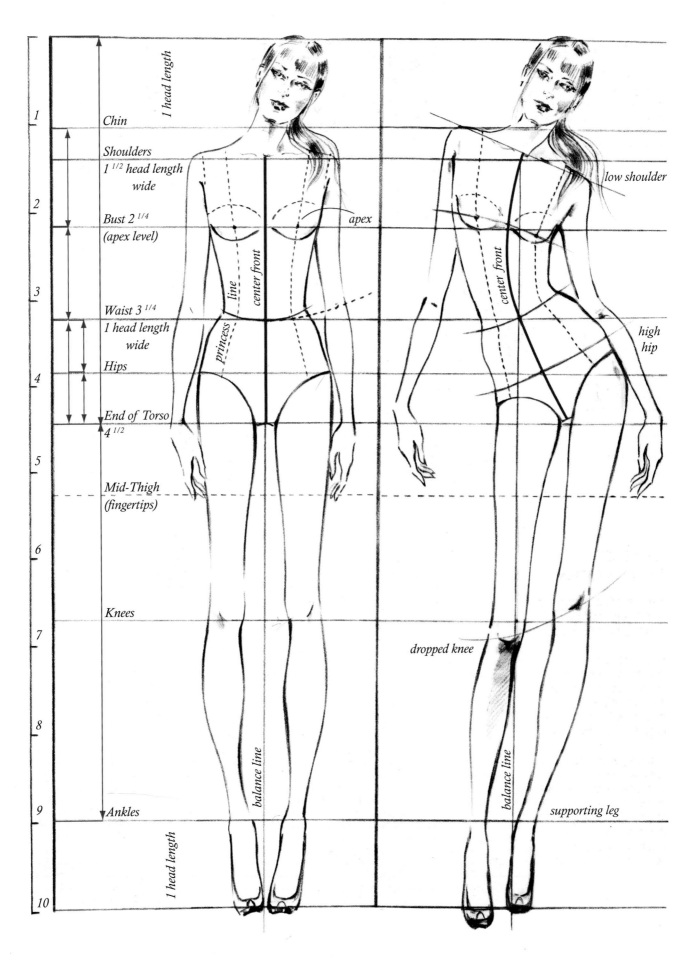

1 head length

1 Chin

Shoulders
1 1/2 head length wide

2 Bust 2 1/4
(apex level)

apex

princess line

center front line

3

Waist 3 1/4
1 head length wide

Hips

4 End of Torso
4 1/2

5

Mid-Thigh
(fingertips)

6

Knees

7

balance line

8

9 Ankles

1 head length

10

low shoulder

center front

high hip

dropped knee

balance line

supporting leg

BALANCE & MOVEMENT

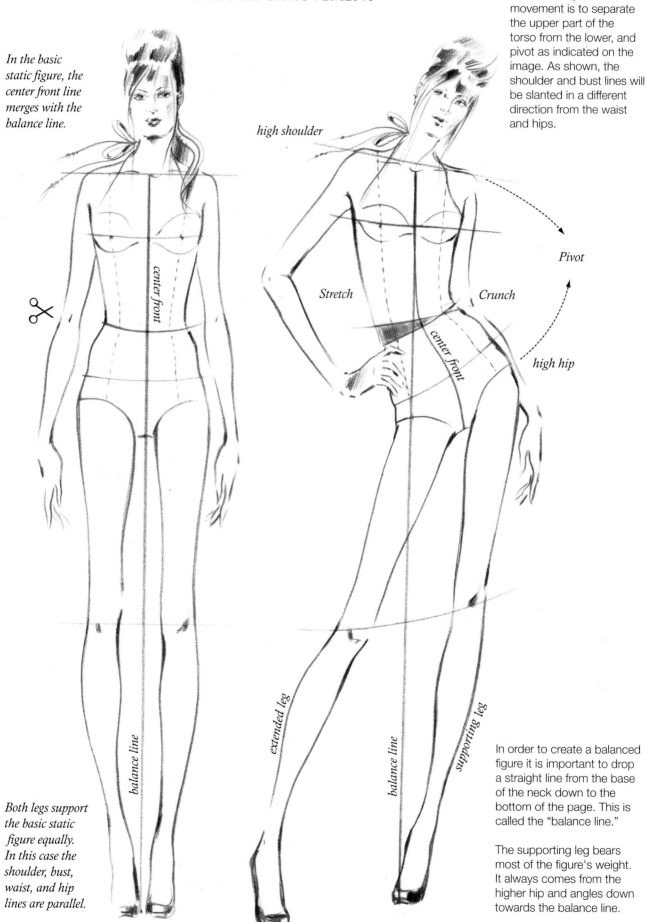

In the basic static figure, the center front line merges with the balance line.

Both legs support the basic static figure equally. In this case the shoulder, bust, waist, and hip lines are parallel.

center front

balance line

high shoulder

Stretch

Crunch

Pivot

center front

high hip

extended leg

balance line

supporting leg

The best way to achieve movement is to separate the upper part of the torso from the lower, and pivot as indicated on the image. As shown, the shoulder and bust lines will be slanted in a different direction from the waist and hips.

In order to create a balanced figure it is important to drop a straight line from the base of the neck down to the bottom of the page. This is called the "balance line."

The supporting leg bears most of the figure's weight. It always comes from the higher hip and angles down towards the balance line.

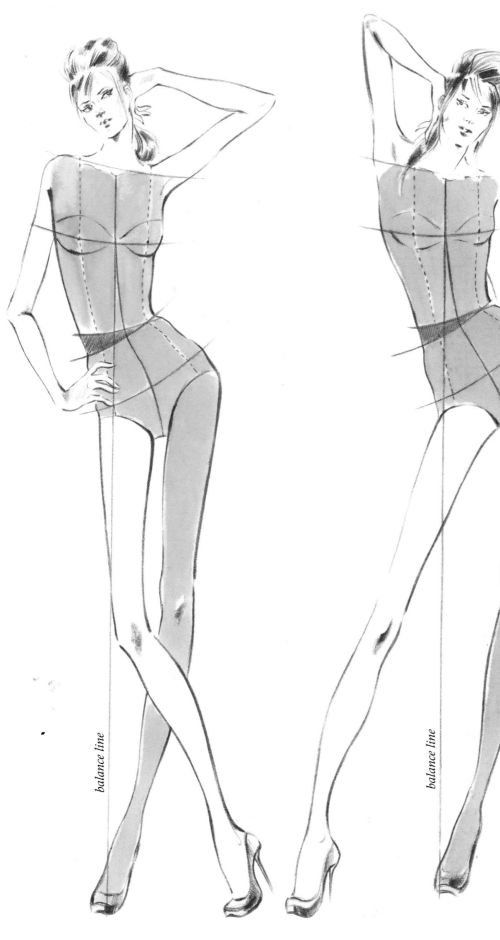

balance line

balance line

When the torso and supporting leg positions are established, as indicated in blue, it becomes possible to manipulate the model's head position, arms, and extended leg to create additional figure variations.

THE WALKING FIGURE

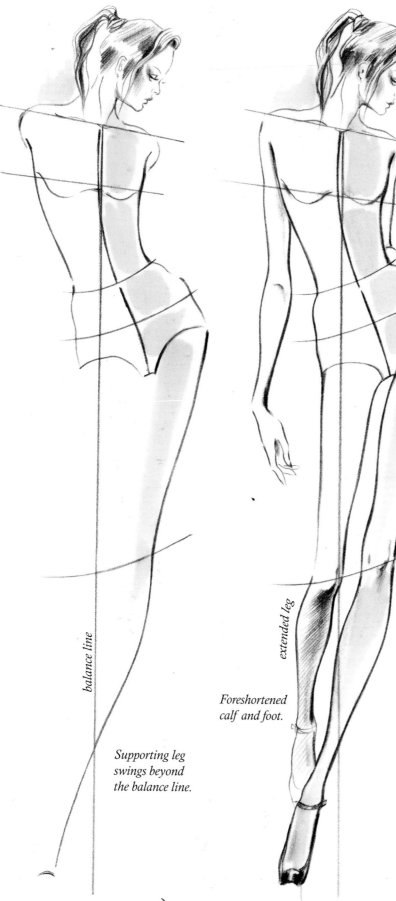

Walking figure, back view.

balance line

extended leg

Foreshortened calf and foot.

Supporting leg swings beyond the balance line.

Dynamic walking figures will create the illusion of a runway show and can become an effective and modern highlight in your fashion portfolio.

The movement of the torso is created in the same way as the front-view figure. The angle of the supporting leg is more exaggerated in the walking figure since all the weight is placed on that leg.

The supporting leg will swing beyond the balance line and the knee of the extended leg will be dropped. The calf and foot of the extended leg are foreshortened to show perspective, while strong shading below the kneecap indicates depth.

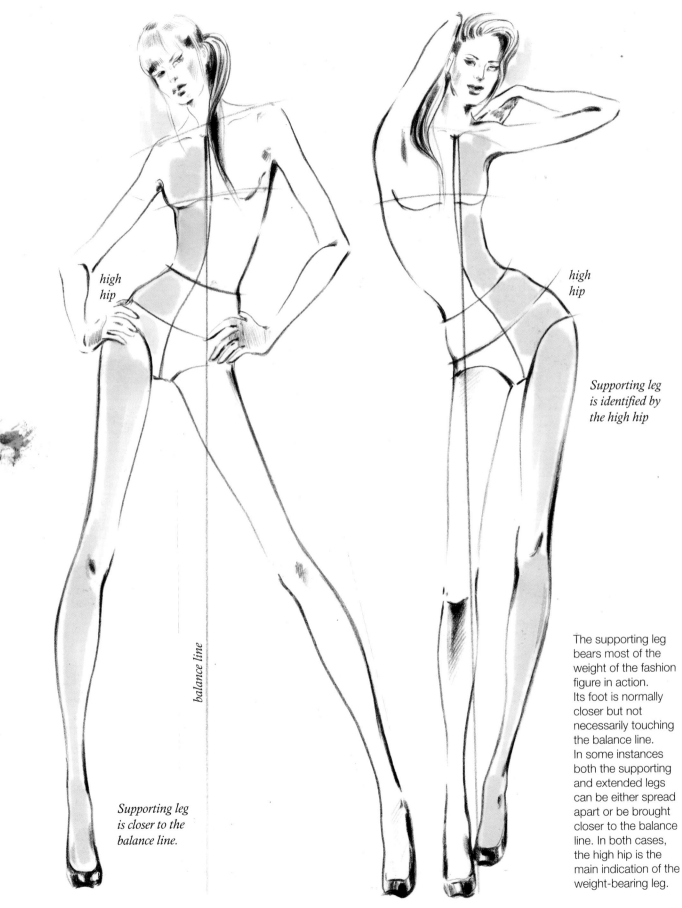

hip

high
hip

*Supporting leg
is identified by
the high hip*

balance line

The supporting leg
bears most of the
weight of the fashion
figure in action.
Its foot is normally
closer but not
necessarily touching
the balance line.
In some instances
both the supporting
and extended legs
can be either spread
apart or be brought
closer to the balance
line. In both cases,
the high hip is the
main indication of the
weight-bearing leg.

*Supporting leg
is closer to the
balance line.*

THE BLOCKING METHOD

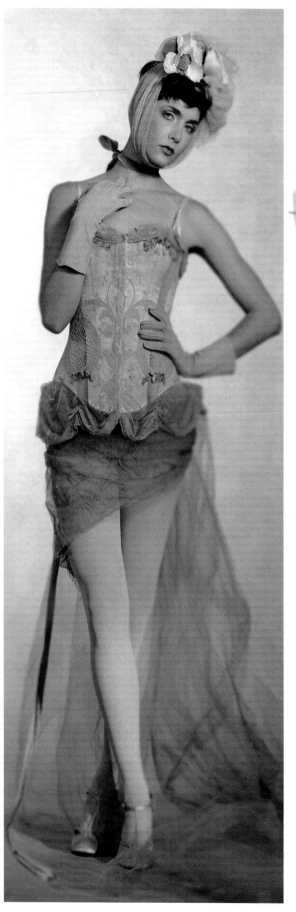

The blocking method is a quick and effective technique to indicate proportions and the general silhouette of the figure:

1. Identify the high hip and supporting leg with a light or skin tone marker. Quickly block the model's head and torso, eye-balling proportions and slightly exaggerating her movement for a dramatic outcome.

2. Drop down the balance line from the base of the neck at center front. Bring the supporting leg to the balance line area.

3. Indicate the movement and proportions of the model's arms.

4. Block ground colours for each part of the outfit and shade the skin tone.

5. Add textures with colour pencils and outline the figure as the last step.

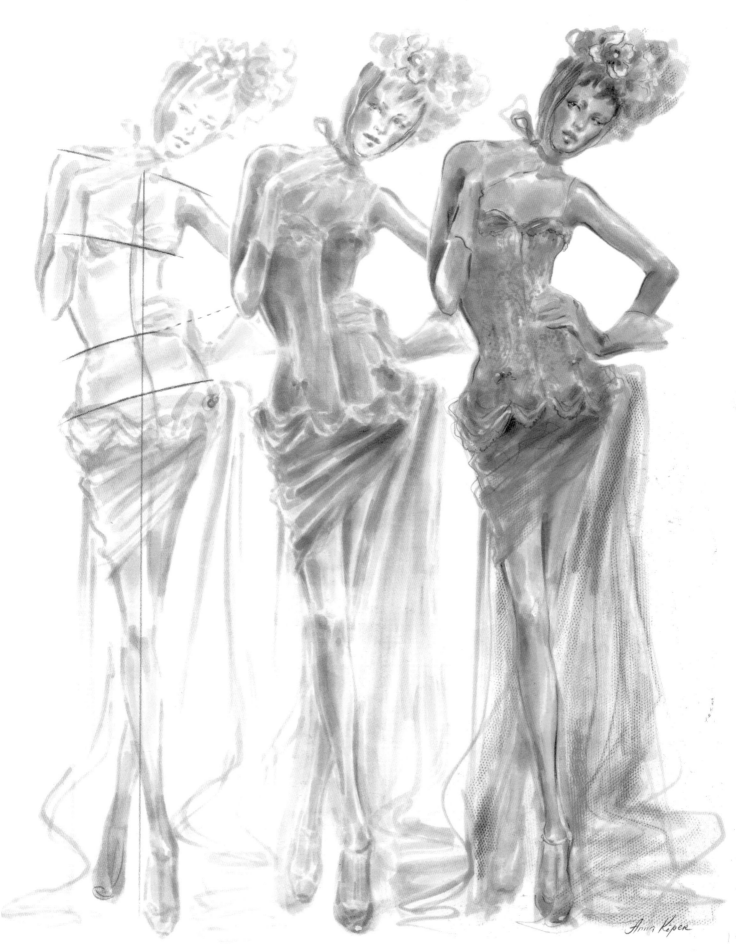

BLOCKING SILHOUETTES

Dressed in layers, the figure can be blocked instantly to capture the final silhouette:

1. Lightly block the figure with a pale-toned marker. Identify the high hip, the supporting leg, and general figure proportions.

2. Use coloured pencils to create the outline, accenting the details.

3. Gradually start layering colours, including the skin tone and the background.

4. Continue with deep shadows and highlights to add dimension and character to the drawing.

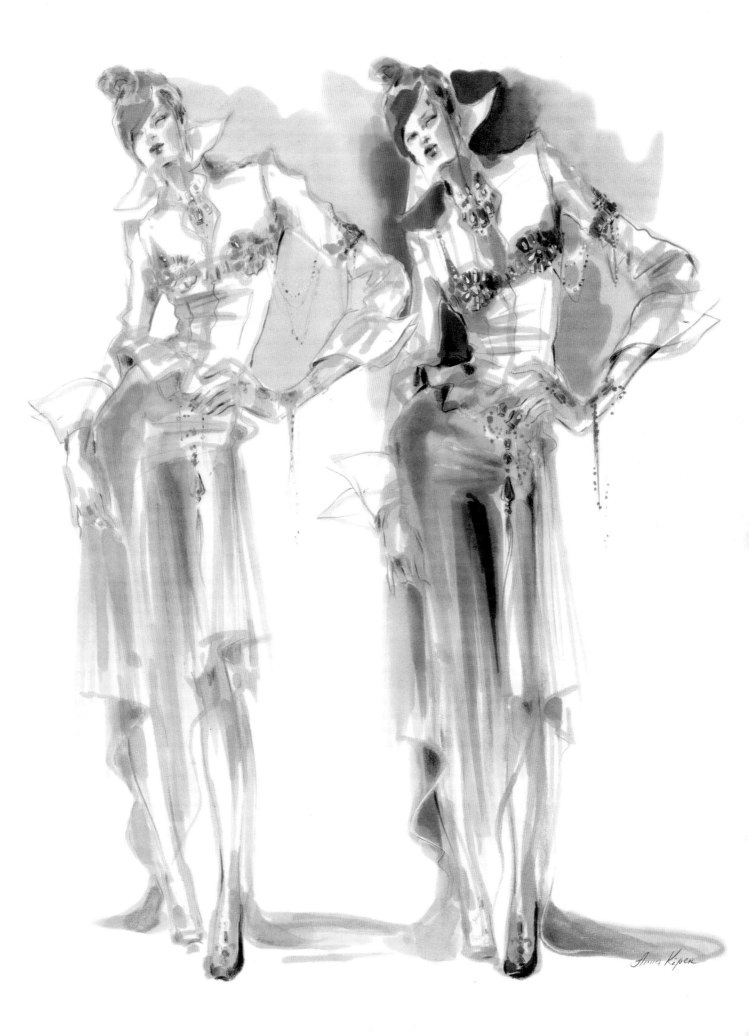

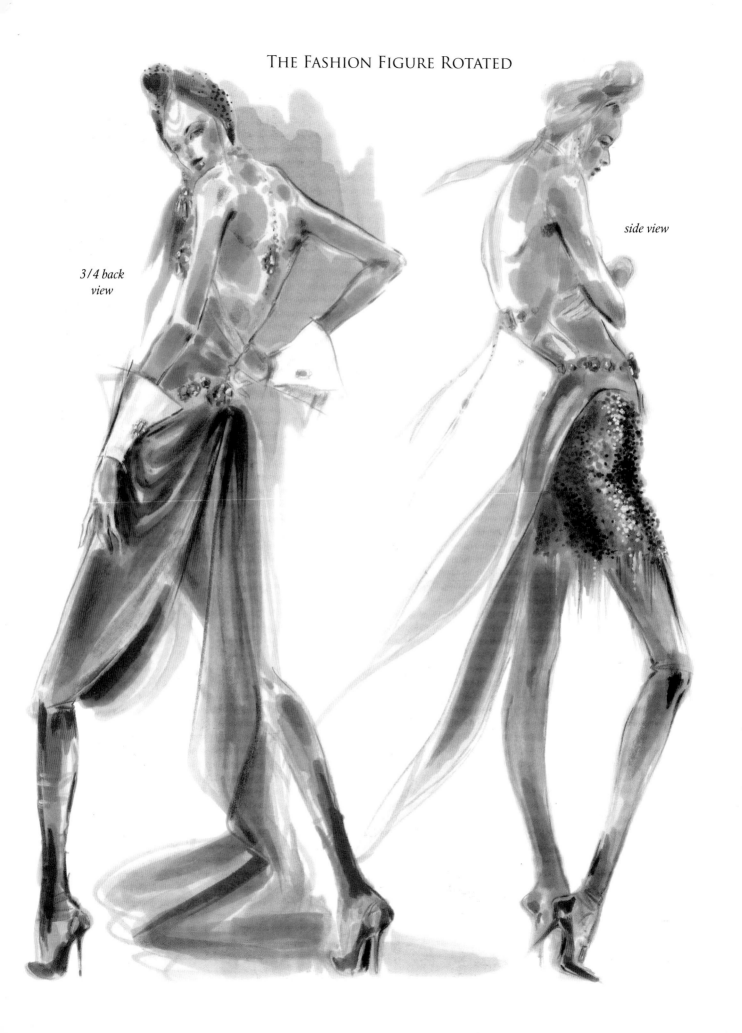

*3/4 back
view*

side view

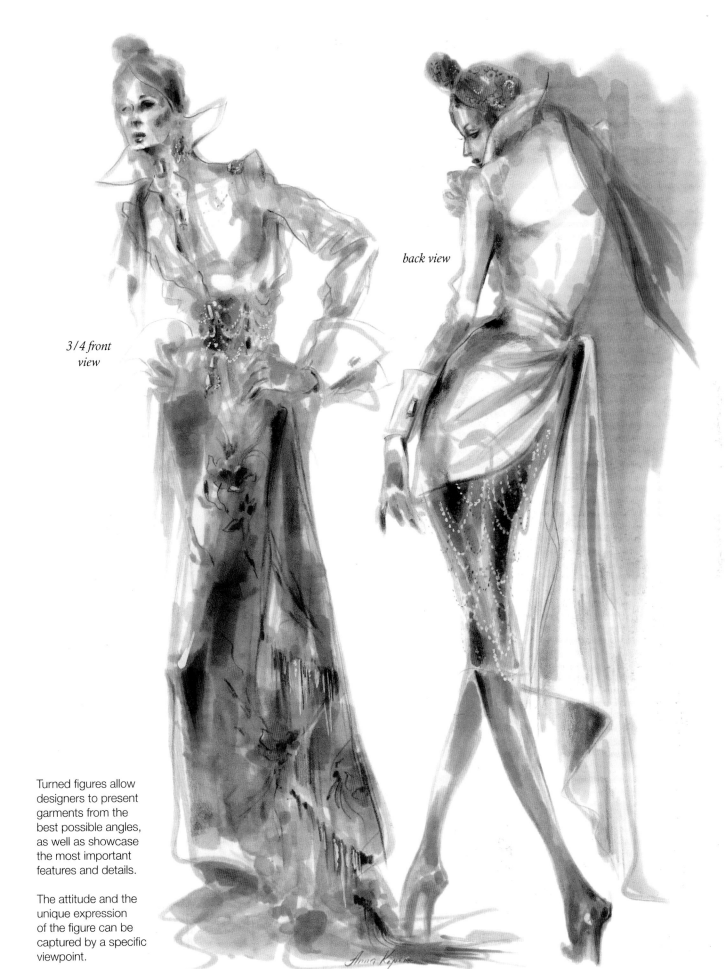

3/4 front view

back view

Turned figures allow designers to present garments from the best possible angles, as well as showcase the most important features and details.

The attitude and the unique expression of the figure can be captured by a specific viewpoint.

3/4 Front View & the Importance of Center Front

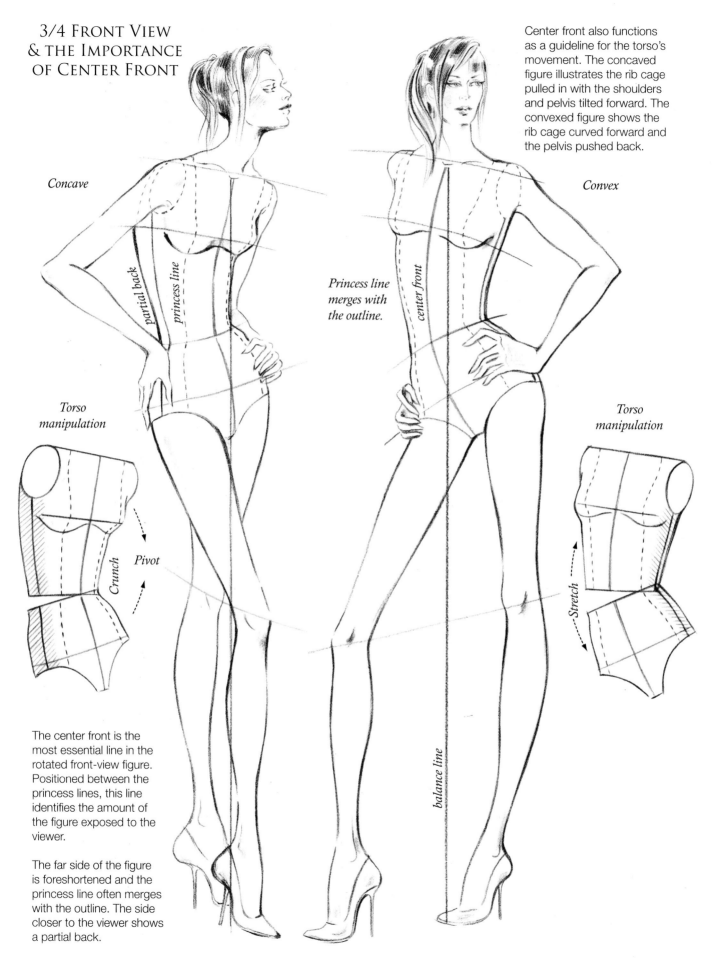

Center front also functions as a guideline for the torso's movement. The concaved figure illustrates the rib cage pulled in with the shoulders and pelvis tilted forward. The convexed figure shows the rib cage curved forward and the pelvis pushed back.

Concave

Convex

partial back

princess line

Princess line merges with the outline.

center front

Torso manipulation

Torso manipulation

Crunch

Pivot

Stretch

balance line

The center front is the most essential line in the rotated front-view figure. Positioned between the princess lines, this line identifies the amount of the figure exposed to the viewer.

The far side of the figure is foreshortened and the princess line often merges with the outline. The side closer to the viewer shows a partial back.

3/4 BACK VIEW & FIGURE IN PERSPECTIVE

In any back view figure, including the ¾ back turn, the center back becomes an important indicator of the torso's movement. The use of perspective creates a sense of space and dimension. Angled guidelines follow upper and lower torso directions and merge into a point of perspective. This creates a foreshortening effect on the far side of the figure.

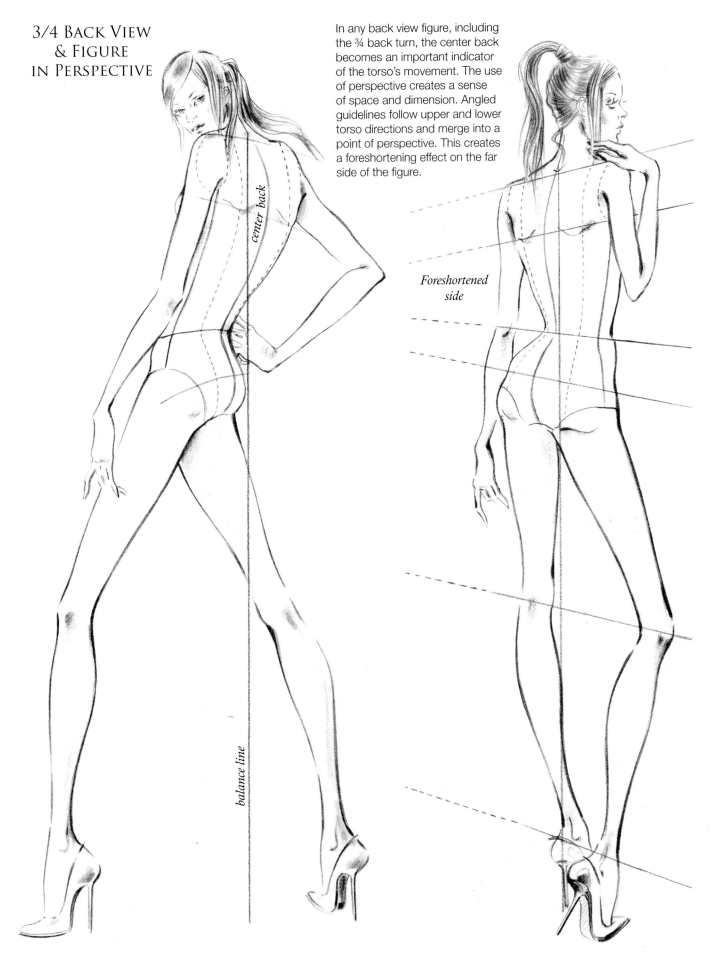

center back

balance line

Foreshortened side

BACK VIEW

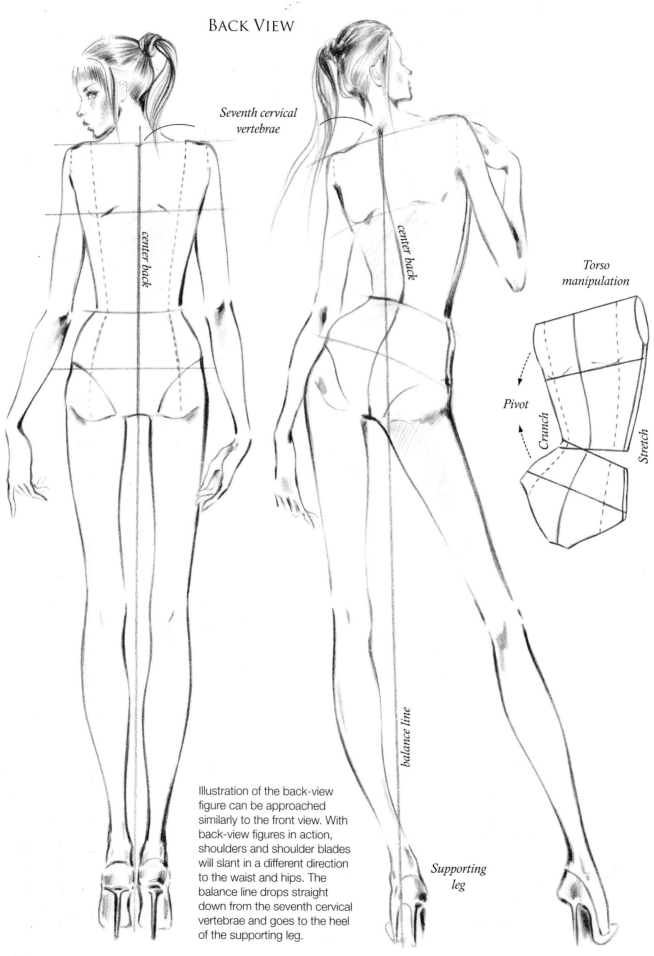

Seventh cervical vertebrae

center back

center back

Torso manipulation

Pivot

Crunch

Stretch

balance line

Supporting leg

Illustration of the back-view figure can be approached similarly to the front view. With back-view figures in action, shoulders and shoulder blades will slant in a different direction to the waist and hips. The balance line drops straight down from the seventh cervical vertebrae and goes to the heel of the supporting leg.

SIDE VIEW

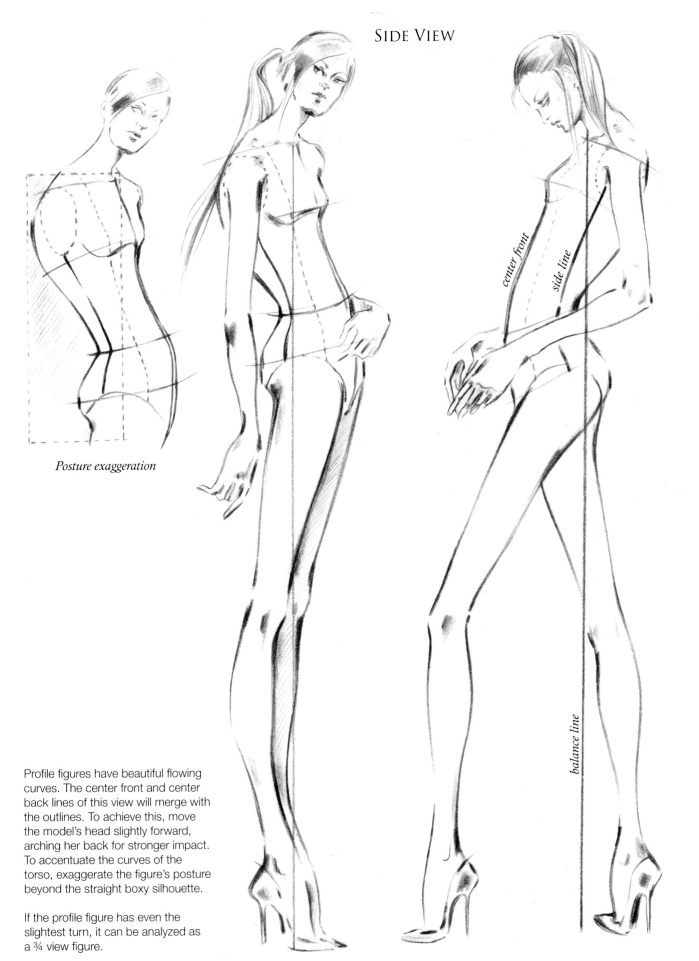

Posture exaggeration

center front

side line

balance line

Profile figures have beautiful flowing curves. The center front and center back lines of this view will merge with the outlines. To achieve this, move the model's head slightly forward, arching her back for stronger impact. To accentuate the curves of the torso, exaggerate the figure's posture beyond the straight boxy silhouette.

If the profile figure has even the slightest turn, it can be analyzed as a ¾ view figure.

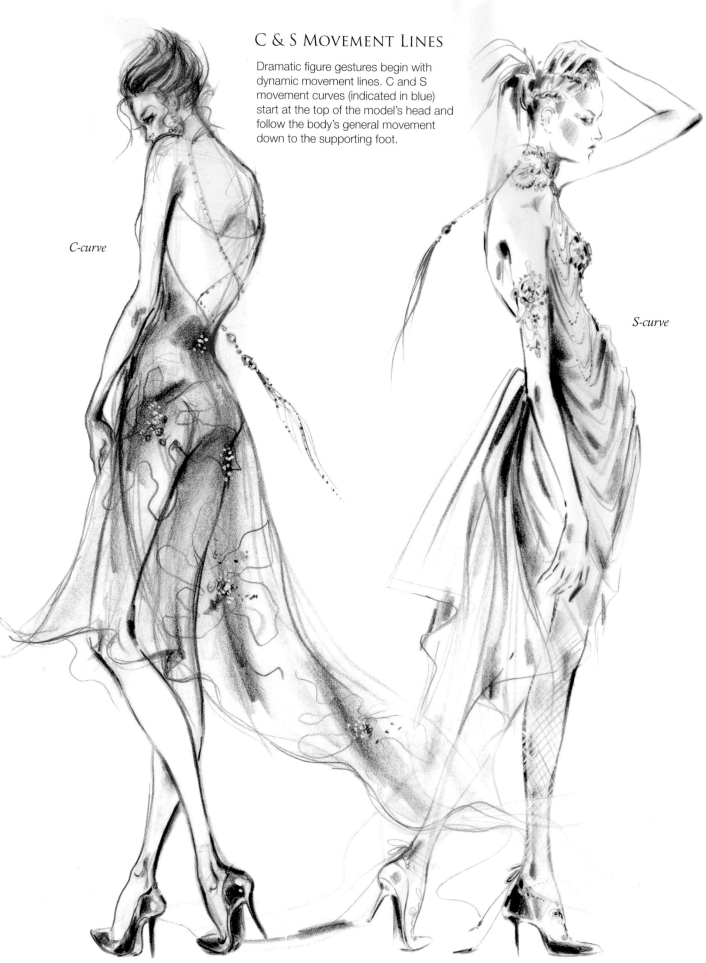

C & S MOVEMENT LINES

Dramatic figure gestures begin with dynamic movement lines. C and S movement curves (indicated in blue) start at the top of the model's head and follow the body's general movement down to the supporting foot.

C-curve

S-curve

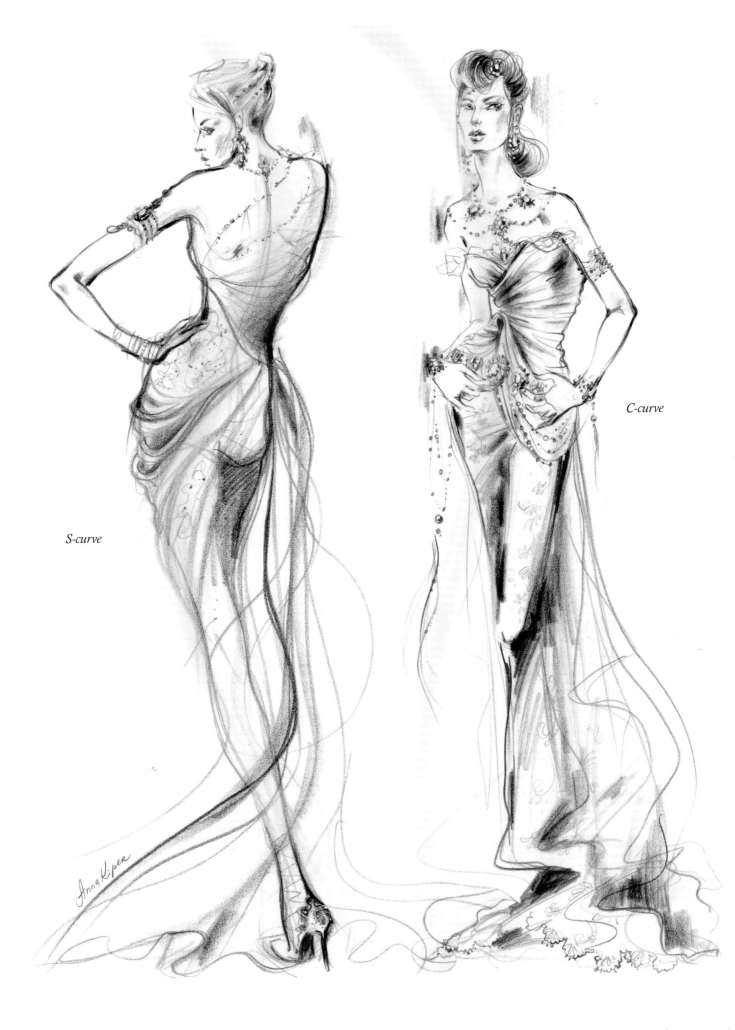

S-curve

C-curve

Anna Kiper

THE FIGURE
IN DETAIL

Nothing shapes individual style better than attention to the figure's form and details: hands, feet, face, and hair. There is no quick recipe for creating a signature style—it is a long creative process requiring experiments with media, techniques, figure proportions, and stylization.

The observation of human anatomy and an understanding of a variety of art forms is essential in developing an artist's aesthetic vision. Exploration and experimentation with these forms fosters artistic originality and sensitivity.

FACES

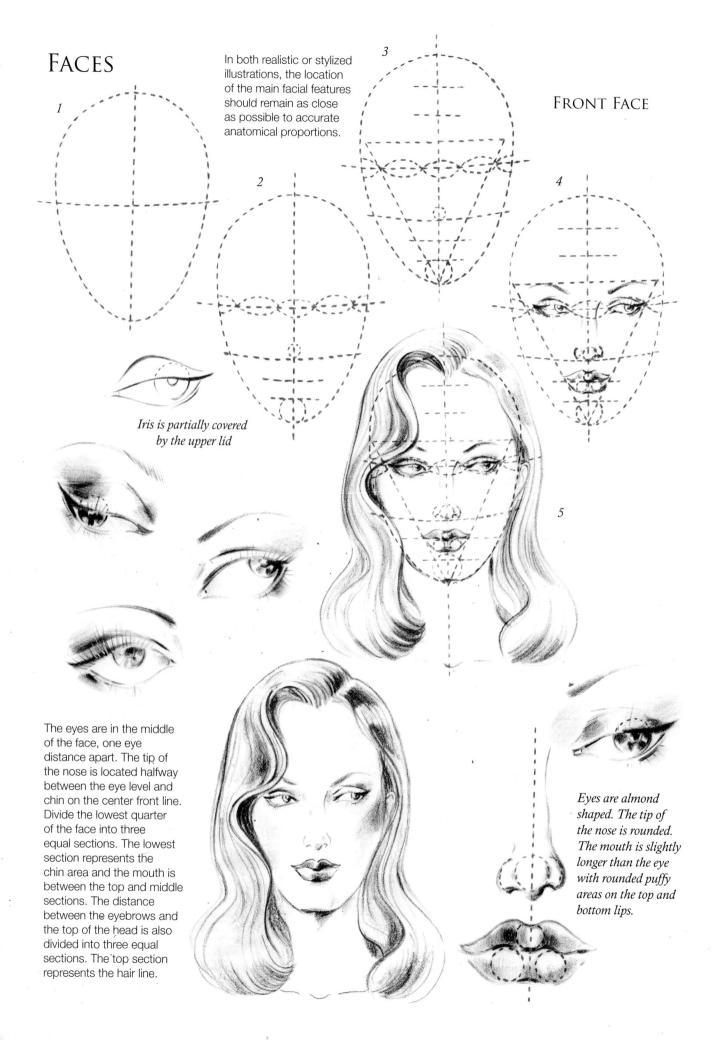

1

In both realistic or stylized illustrations, the location of the main facial features should remain as close as possible to accurate anatomical proportions.

3

FRONT FACE

2

4

Iris is partially covered by the upper lid

5

The eyes are in the middle of the face, one eye distance apart. The tip of the nose is located halfway between the eye level and chin on the center front line. Divide the lowest quarter of the face into three equal sections. The lowest section represents the chin area and the mouth is between the top and middle sections. The distance between the eyebrows and the top of the head is also divided into three equal sections. The top section represents the hair line.

Eyes are almond shaped. The tip of the nose is rounded. The mouth is slightly longer than the eye with rounded puffy areas on the top and bottom lips.

3/4 FACE

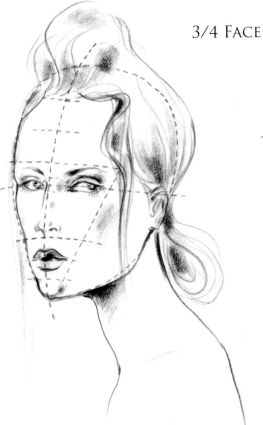

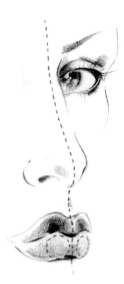

The center front line of the ¾ face is shifted according to the degree of the turn. Front face proportions remain the same on the side of the face closest to the viewer. The far side of the face is foreshortened. The length of the foreshortened eye should be reduced. The far corner of the foreshortened side of the mouth should be brought closer to the center front line. The bridge of the nose is more pronounced and the far nostril is barely visible.

PROFILE

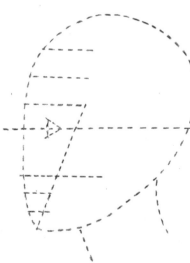

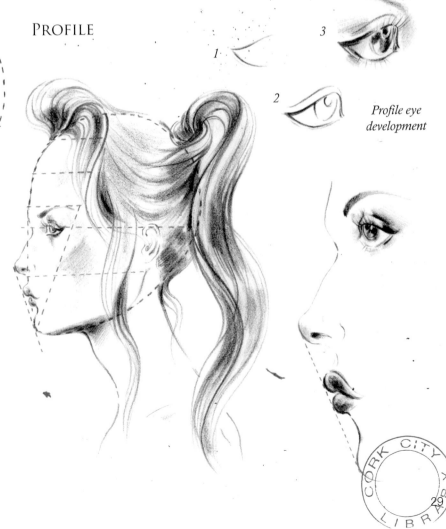

1

2

3

Profile eye development

In profile view, the oval shape of the head is slightly tilted and the forehead and bridge of the nose become part of the outline contour of the face. The mouth and chin are placed on an angle for a more feminine look. The profile eye is severely foreshortened, and the iris is oval shaped and sits inside the lids. Jaw and neck lines start at the chin as one, and split as the upper line curves to the ear and the lower line forms the neck outline. Place a strong shadow underneath the chin.

UP & DOWN FACES

For down-turned
views, slightly stretch
the head oval and
bring the eye level
down. The chin covers
most of the neck, while
the bridge of the nose
is elongated, and the
top lip becomes a thin
line. Emphasis is on
the forehead and hair.

View up

For up-turned views, foreshorten
the length of the face by curving
up the chin line. The eye level is
raised, and the bridge of the nose
is foreshortened with a strong
emphasis on the mouth and chin.
This is an excellent view for big
collars and necklaces, due to the
elongated neck.

View down

View up-turned

View down-turned

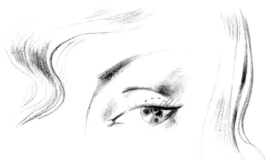

SHADING FACES

Faces do not need excessive shading. There are a few crucial areas where the shadows must be placed: around the eyes, next to the bridge of the nose, around the temples, and under the chin. Cheekbones should be emphasized with light shading,

Touches of shading are normally placed around and under the tip of the nose, emphasizing its dimensions. The upper lip is always darker than the lower one and a smear of shadow can be placed under the bottom lip with a bright highlight on top of it.

ILLUSTRATING HATS

Head outline

Hats sit on the crown of the head. Brims wrap securely around the head and often cover the forehead and eyebrows. This can create a need for more intense shading of the face.

DRAWING HAIR

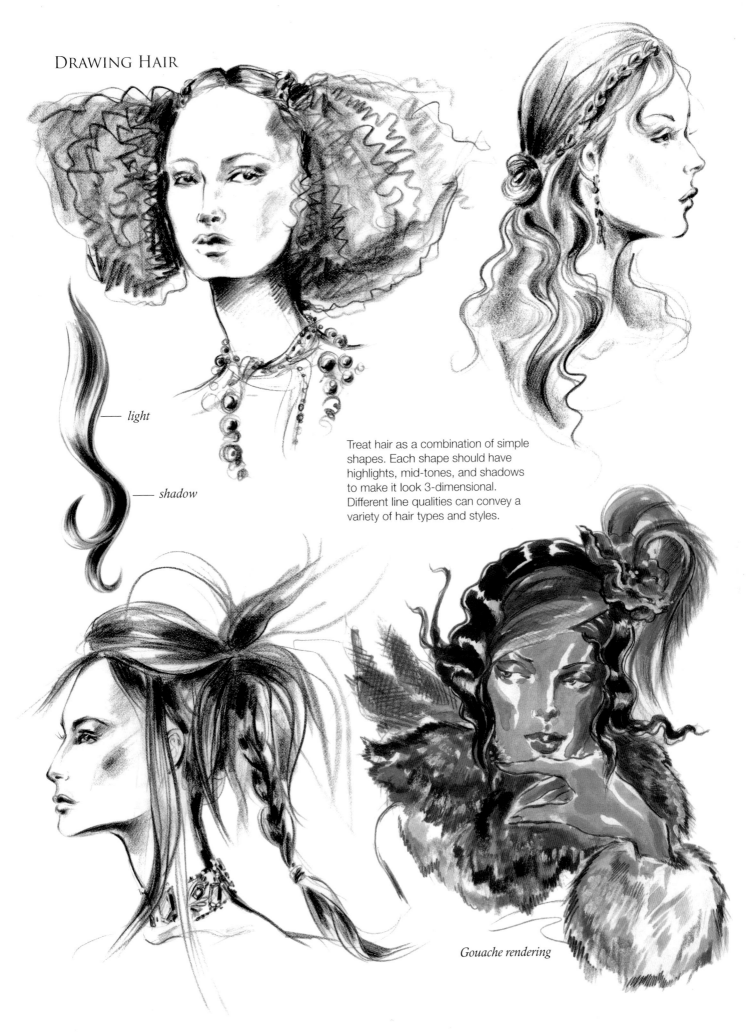

light

shadow

Treat hair as a combination of simple shapes. Each shape should have highlights, mid-tones, and shadows to make it look 3-dimensional. Different line qualities can convey a variety of hair types and styles.

Gouache rendering

THE FACE COLOURED IN STAGES

After achieving the detailed outline of the face (step 1), choose a skin tone colour to emphasize all shaded areas of the face: temples, the eye area, and under the cheekbones, chin, and mouth. Leave highlights on the forehead, bridge, and tip of the nose (step 2). Then add dimension and texture to hair and accessories (step 3).

step 1

step 2

An exciting variety of skin tones are available in any marker brand. Cooler or warmer shades can be selected for any skin tone variations of any ethnic group. Along with colour differences, specific ethnic features can be emphasized: higher cheek-bones, broader noses, narrow elongated eyes, and fuller lips (opposite page).

step 3

34

Skin Tones

pale peach

pale flesh

buff

light walnut

sand

desert tan

kraft brown

ARMS & HANDS

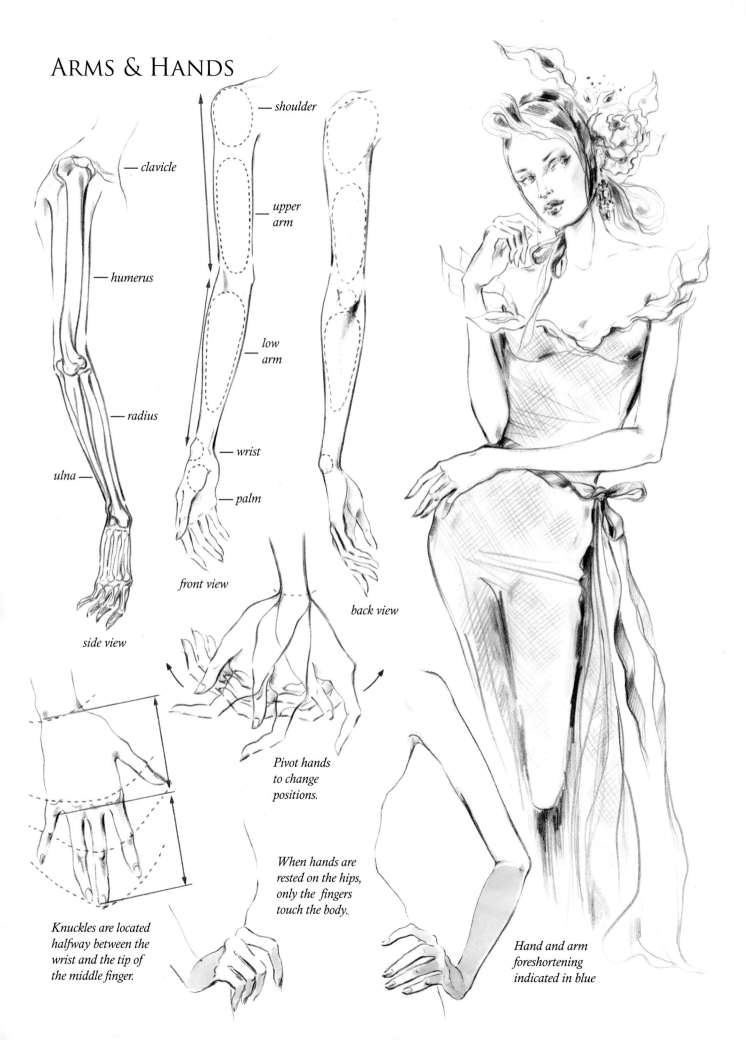

— clavicle

— humerus

— radius

ulna —

side view

— shoulder

— upper arm

— low arm

— wrist

— palm

front view

back view

Pivot hands to change positions.

When hands are rested on the hips, only the fingers touch the body.

Knuckles are located halfway between the wrist and the tip of the middle finger.

Hand and arm foreshortening indicated in blue

Beautifully illustrated arms and hands can enhance any fashion drawing. The following are crucial:

1. Arms never hang straight, but have a slight natural bend.

2. Arms are rounded. The outline gently curves in and out accommodating bones and muscle structure.

3. The distance from shoulder to elbow equals the distance from elbow to wrist.

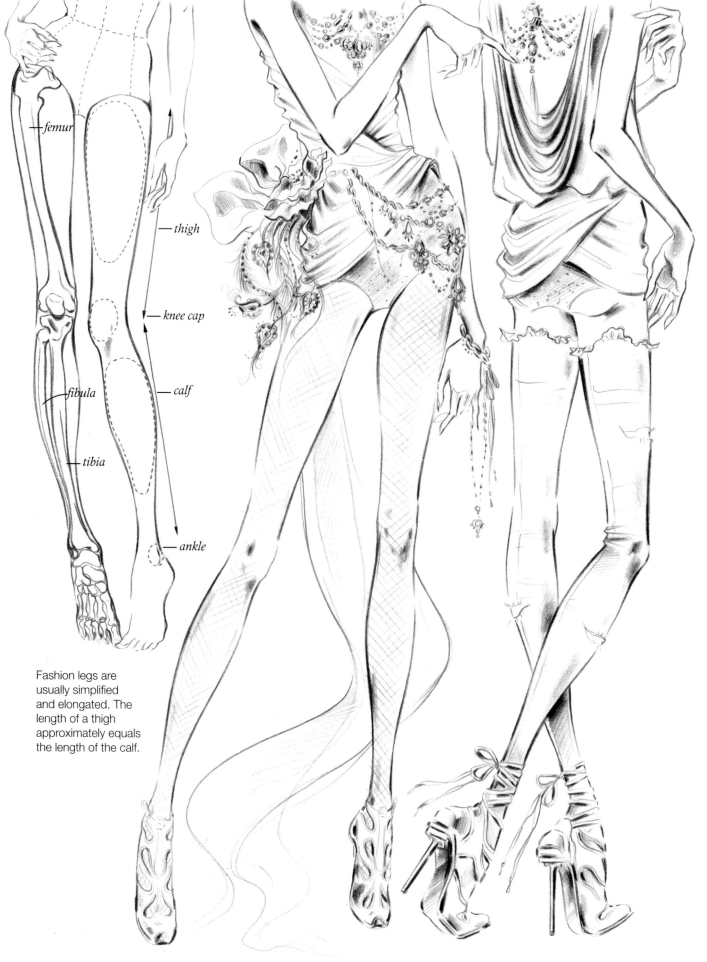

femur

thigh

knee cap

calf

fibula

tibia

ankle

Fashion legs are
usually simplified
and elongated. The
length of a thigh
approximately equals
the length of the calf.

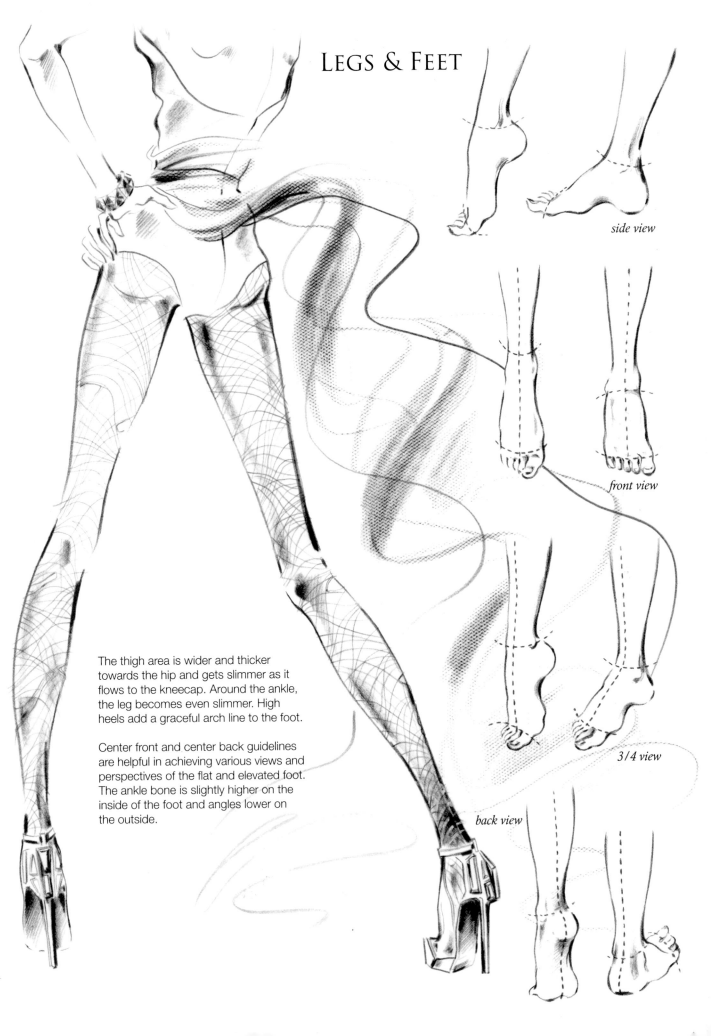

LEGS & FEET

side view

front view

3/4 view

back view

The thigh area is wider and thicker towards the hip and gets slimmer as it flows to the kneecap. Around the ankle, the leg becomes even slimmer. High heels add a graceful arch line to the foot.

Center front and center back guidelines are helpful in achieving various views and perspectives of the flat and elevated foot. The ankle bone is slightly higher on the inside of the foot and angles lower on the outside.

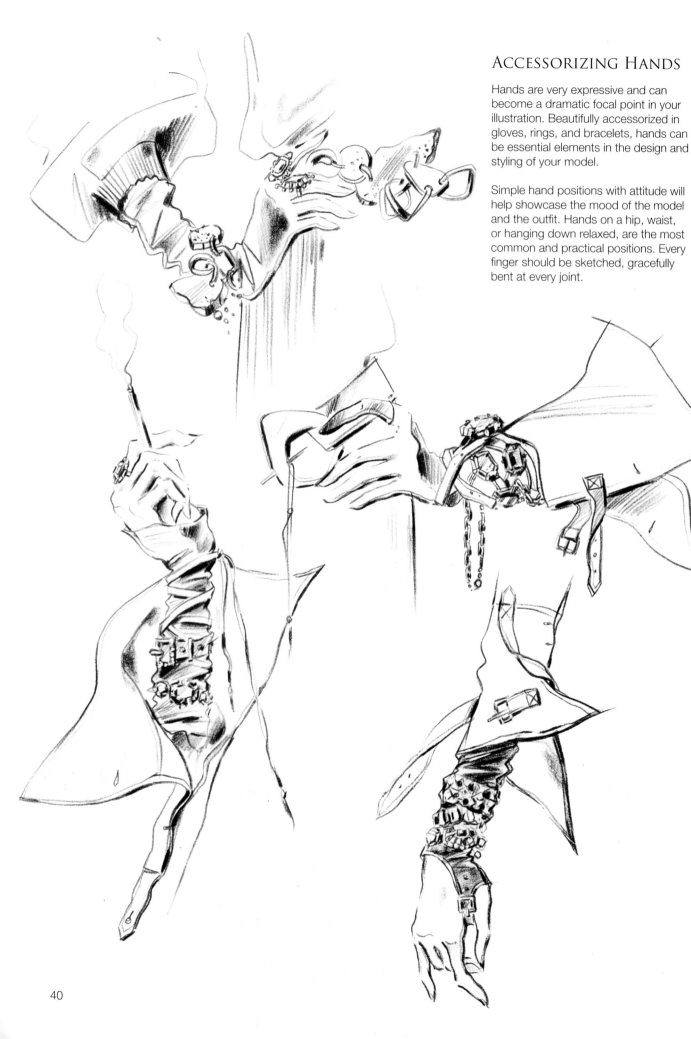

ACCESSORIZING HANDS

Hands are very expressive and can become a dramatic focal point in your illustration. Beautifully accessorized in gloves, rings, and bracelets, hands can be essential elements in the design and styling of your model.

Simple hand positions with attitude will help showcase the mood of the model and the outfit. Hands on a hip, waist, or hanging down relaxed, are the most common and practical positions. Every finger should be sketched, gracefully bent at every joint.

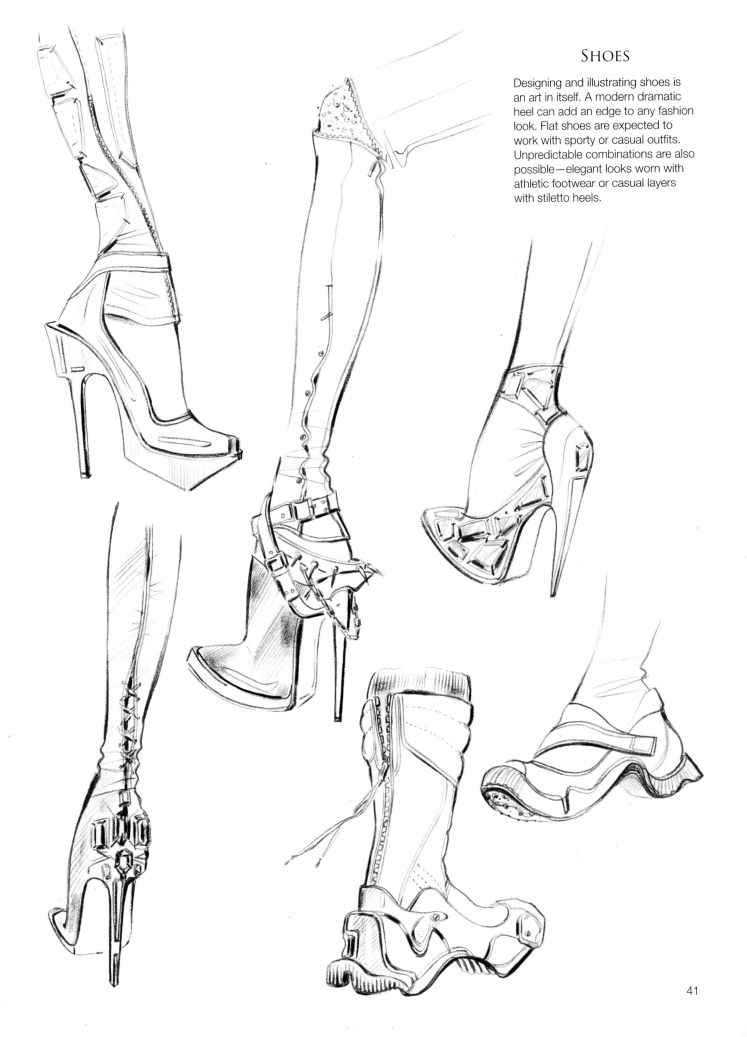

SHOES

Designing and illustrating shoes is an art in itself. A modern dramatic heel can add an edge to any fashion look. Flat shoes are expected to work with sporty or casual outfits. Unpredictable combinations are also possible—elegant looks worn with athletic footwear or casual layers with stiletto heels.

DRESSING THE FASHION FIGURE
CLOTHES AS PART OF THE PAGE COMPOSITION

Exaggerated figures and garment details create dramatic positive and negative space on the page.

Showcasing clothes while making an editorial statement is the main purpose of fashion illustration. Style and attitude can be achieved through the design of positive and negative spaces. The layering of clothes and the use of accessories can help shape the silhouette. The more exaggerated the figure, the more dramatic the negative space will be.

Try to stay focused—emphasize only the most important elements of the outfit. Superimposing contrasting elements in one look or composition often creates unexpectedly strong focal points, (i.e. a micro mini skirt and a ground sweeping coat as one look).

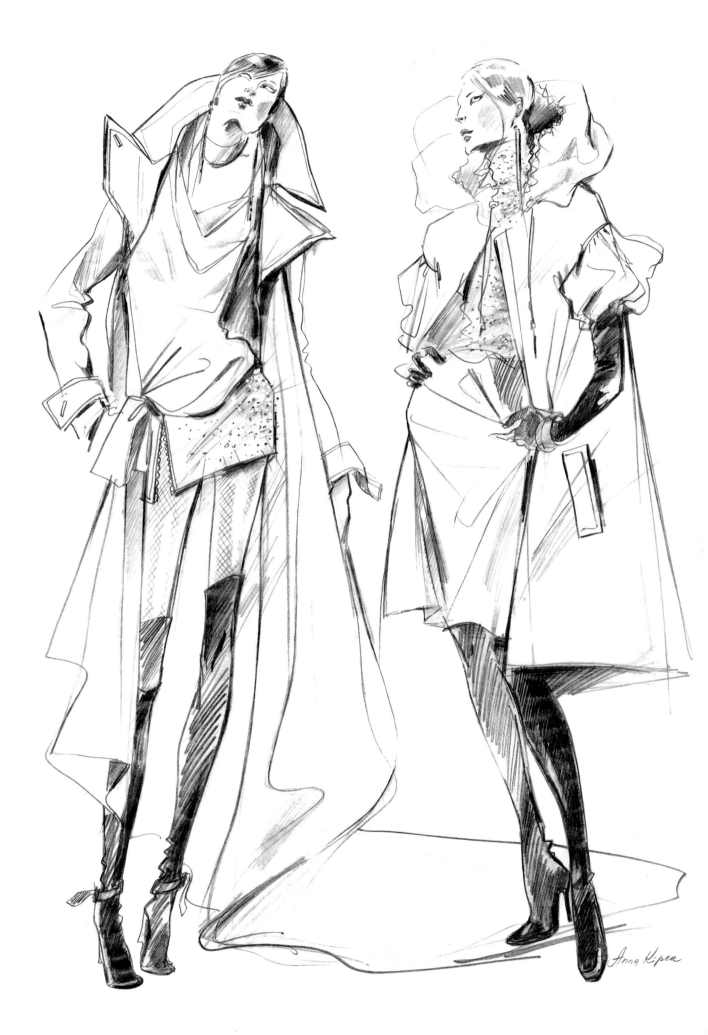

Anna Kiper

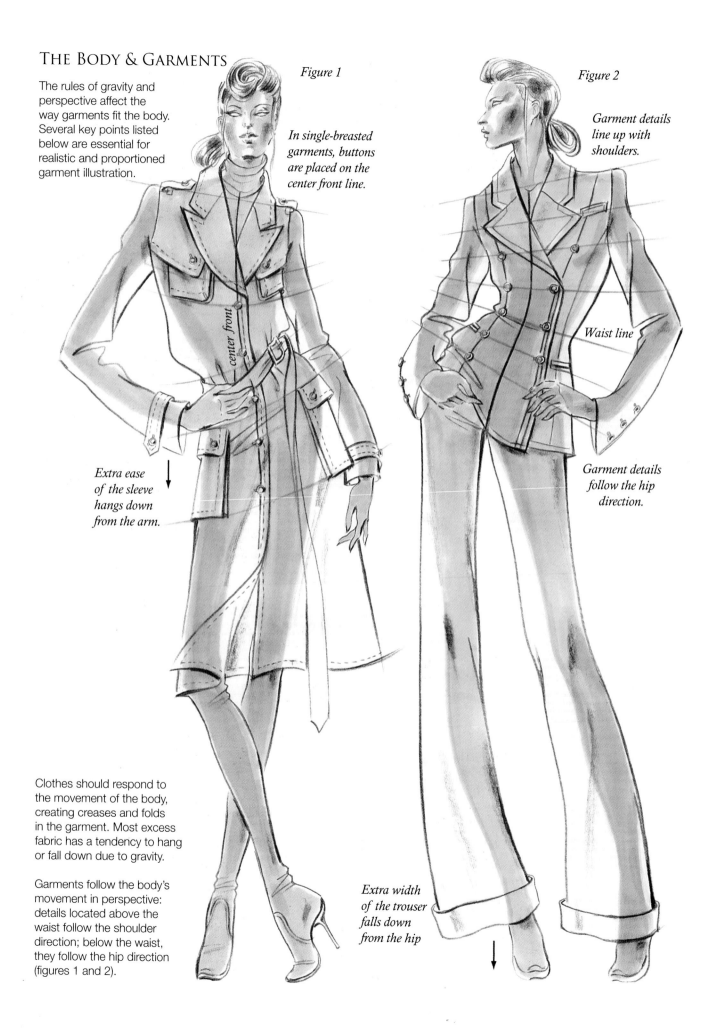

THE BODY & GARMENTS

The rules of gravity and perspective affect the way garments fit the body. Several key points listed below are essential for realistic and proportioned garment illustration.

Figure 1

In single-breasted garments, buttons are placed on the center front line.

center front

Extra ease of the sleeve hangs down from the arm.

Clothes should respond to the movement of the body, creating creases and folds in the garment. Most excess fabric has a tendency to hang or fall down due to gravity.

Garments follow the body's movement in perspective: details located above the waist follow the shoulder direction; below the waist, they follow the hip direction (figures 1 and 2).

Figure 2

Garment details line up with shoulders.

Waist line

Garment details follow the hip direction.

Extra width of the trouser falls down from the hip

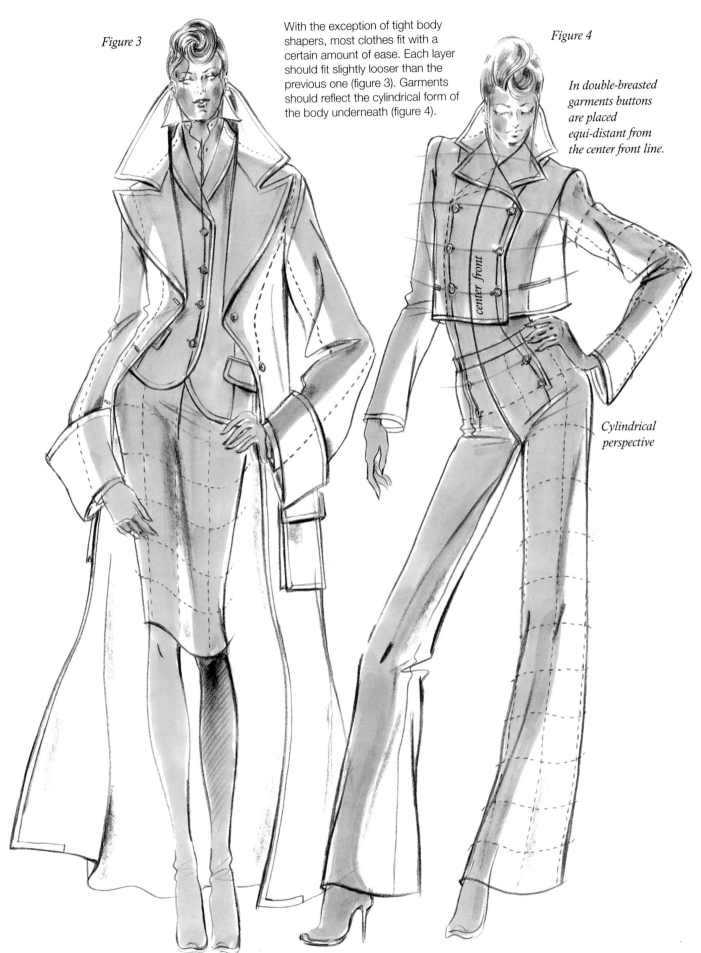

Figure 3

With the exception of tight body shapers, most clothes fit with a certain amount of ease. Each layer should fit slightly looser than the previous one (figure 3). Garments should reflect the cylindrical form of the body underneath (figure 4).

Figure 4

In double-breasted garments buttons are placed equi-distant from the center front line.

center front

Cylindrical perspective

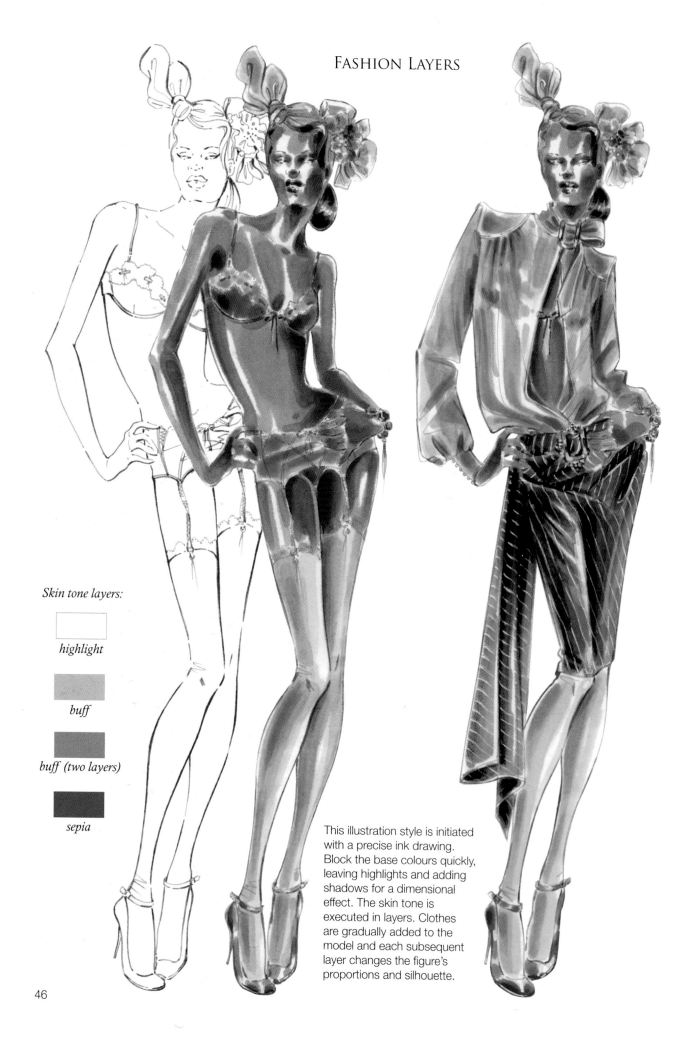

FASHION LAYERS

Skin tone layers:

highlight

buff

buff (two layers)

sepia

This illustration style is initiated with a precise ink drawing. Block the base colours quickly, leaving highlights and adding shadows for a dimensional effect. The skin tone is executed in layers. Clothes are gradually added to the model and each subsequent layer changes the figure's proportions and silhouette.

46

Fabric volume can completely overwhelm the figure and can make it difficult to see the body's shape and proportions. Each garment layer will shape the silhouette of the figure according to its construction and style.

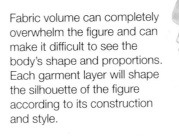

Dressing with Attitude

Trench wrapped and belted.

WATERCOLOUR

Trench partially buttoned and pushed back.

GOUACHE

48

*Trench is fully
opened.*
MARKERS

Trench off the shoulders. *Trench on the shoulders.*

A change in the figure's
attitude, ever so slightly,
can modify the perception
of a look. Different ways of
styling a single outfit can
also create a variety of
looks, and garments can be
modernized by incorporating
accessories. Contradictory
styling and poses are often
used in fashion illustration
and photography to convey
a specific mood and
attitude.

FASHION DICTIONARY

NECESSARY BASICS

For many decades a tailored classic jacket, whether single- or double-breasted, has been a staple of any women's wardrobe. Shown below are variations of the basic fitted jacket with a variety of construction details.

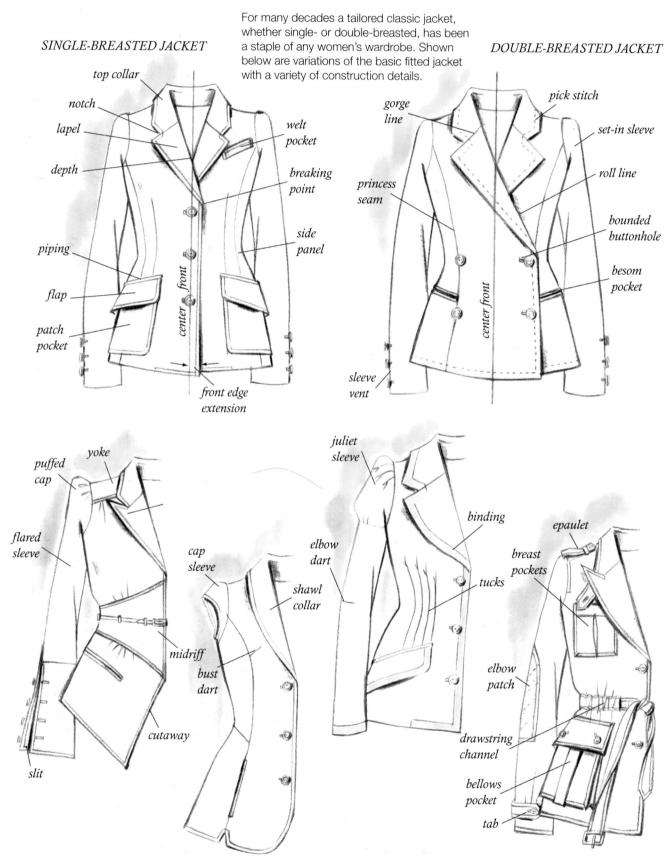

SINGLE-BREASTED JACKET

DOUBLE-BREASTED JACKET

top collar
notch
lapel
depth
welt pocket
breaking point
side panel
piping
center front
flap
patch pocket
front edge extension

gorge line
pick stitch
set-in sleeve
princess seam
roll line
bounded buttonhole
besom pocket
center front
sleeve vent

puffed cap
yoke
flared sleeve
cap sleeve
midriff
bust dart
cutaway
slit

juliet sleeve
binding
elbow dart
tucks
shawl collar

epaulet
breast pockets
elbow patch
drawstring channel
bellows pocket
tab

SKIRT SILHOUETTES

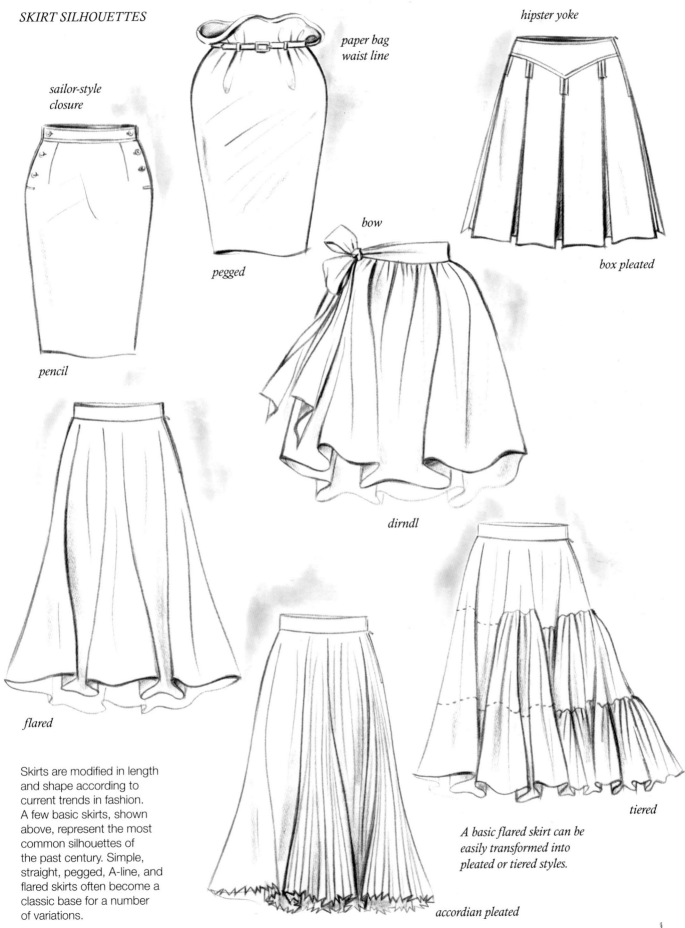

sailor-style closure

pegged

paper bag waist line

hipster yoke

box pleated

bow

pencil

dirndl

flared

tiered

Skirts are modified in length and shape according to current trends in fashion. A few basic skirts, shown above, represent the most common silhouettes of the past century. Simple, straight, pegged, A-line, and flared skirts often become a classic base for a number of variations.

A basic flared skirt can be easily transformed into pleated or tiered styles.

accordian pleated

ACTIVE/SPORT

The utilitarian functionality of activewear explains the amount of details and hardware found on these garments.

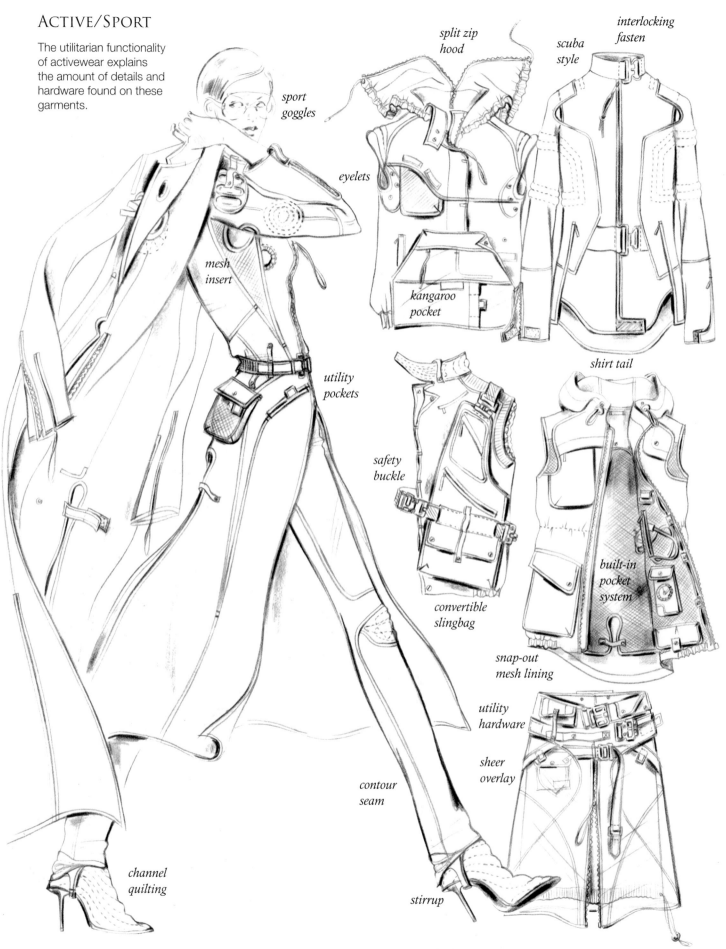

sport goggles

split zip hood

scuba style

interlocking fasten

eyelets

mesh insert

kangaroo pocket

shirt tail

utility pockets

safety buckle

built-in pocket system

convertible slingbag

snap-out mesh lining

utility hardware

sheer overlay

contour seam

channel quilting

stirrup

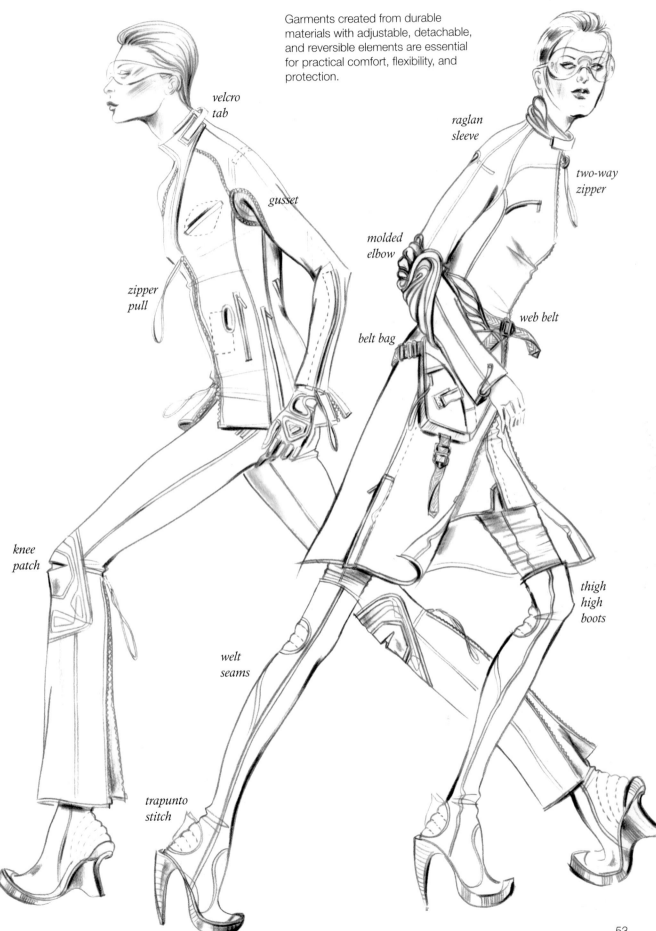

Garments created from durable materials with adjustable, detachable, and reversible elements are essential for practical comfort, flexibility, and protection.

velcro tab

raglan sleeve

two-way zipper

gusset

molded elbow

zipper pull

web belt

belt bag

knee patch

thigh high boots

welt seams

trapunto stitch

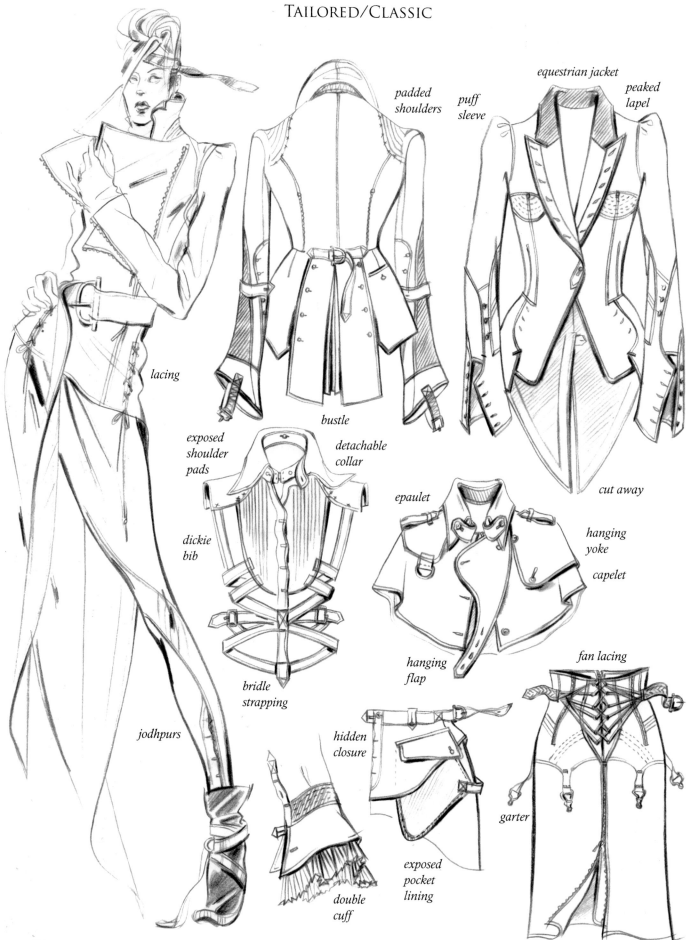

padded
shoulders

puff
sleeve

equestrian jacket

peaked
lapel

lacing

bustle

cut away

exposed
shoulder
pads

detachable
collar

epaulet

hanging
yoke

capelet

dickie
bib

hanging
flap

fan lacing

bridle
strapping

jodhpurs

hidden
closure

garter

double
cuff

exposed
pocket
lining

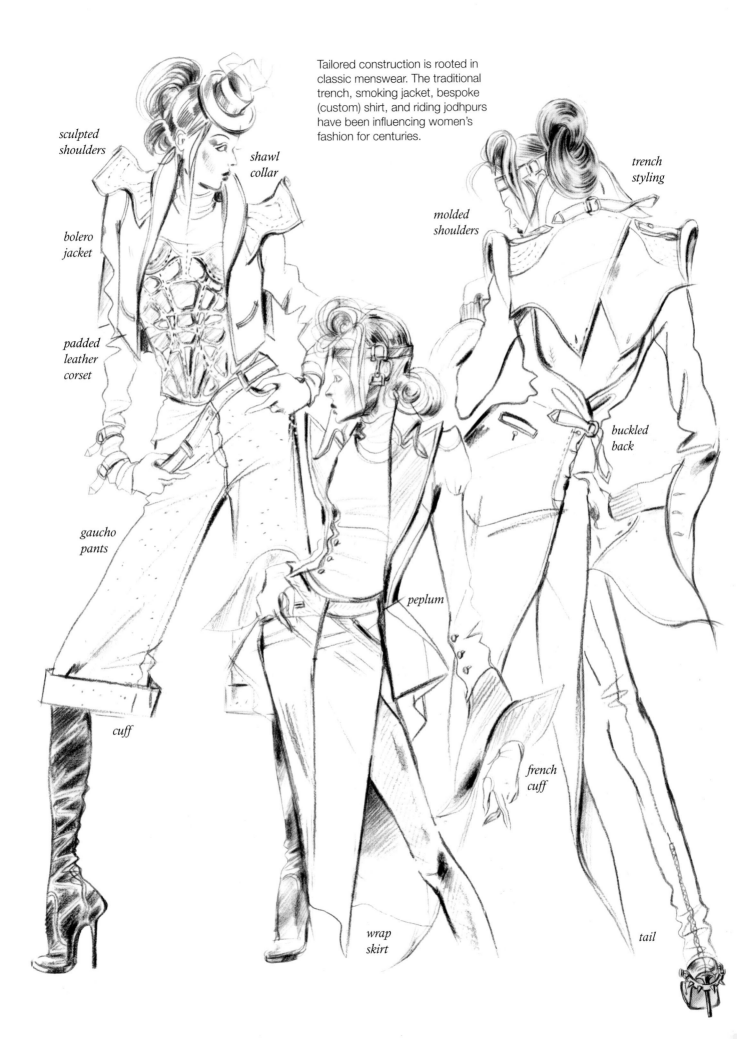

sculpted
shoulders

shawl
collar

bolero
jacket

padded
leather
corset

gaucho
pants

cuff

Tailored construction is rooted in
classic menswear. The traditional
trench, smoking jacket, bespoke
(custom) shirt, and riding jodhpurs
have been influencing women's
fashion for centuries.

molded
shoulders

trench
styling

buckled
back

peplum

french
cuff

wrap
skirt

tail

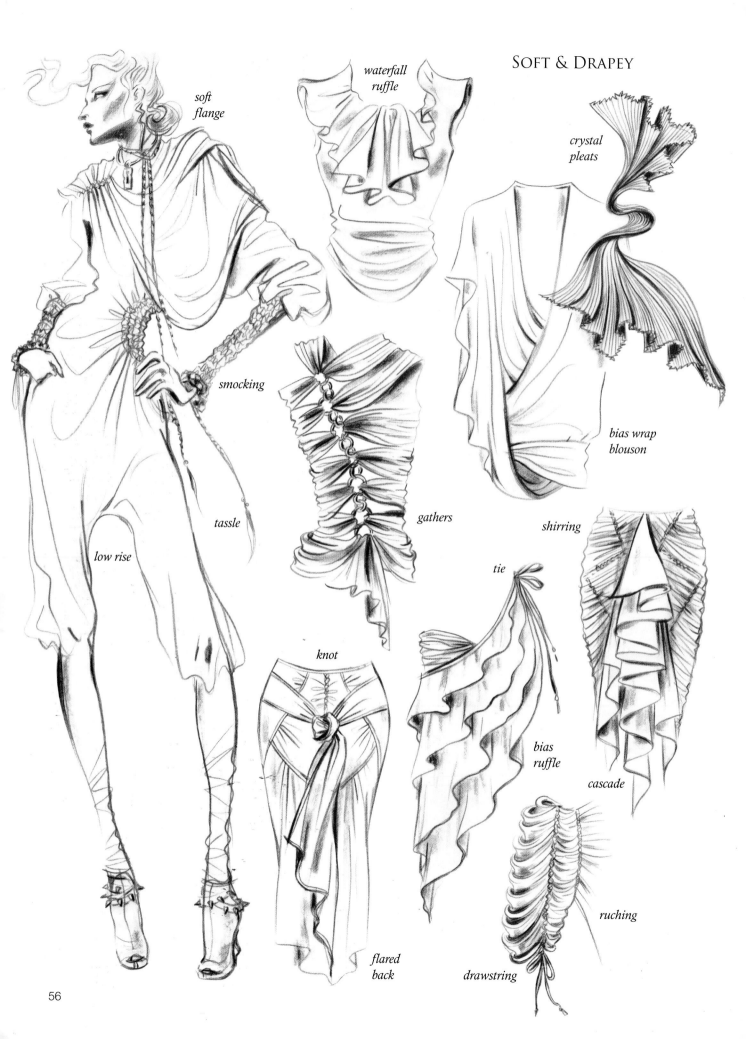

soft
flange

waterfall
ruffle

crystal
pleats

smocking

bias wrap
blouson

tassle

gathers

shirring

low rise

tie

knot

flared
back

bias
ruffle

cascade

drawstring

ruching

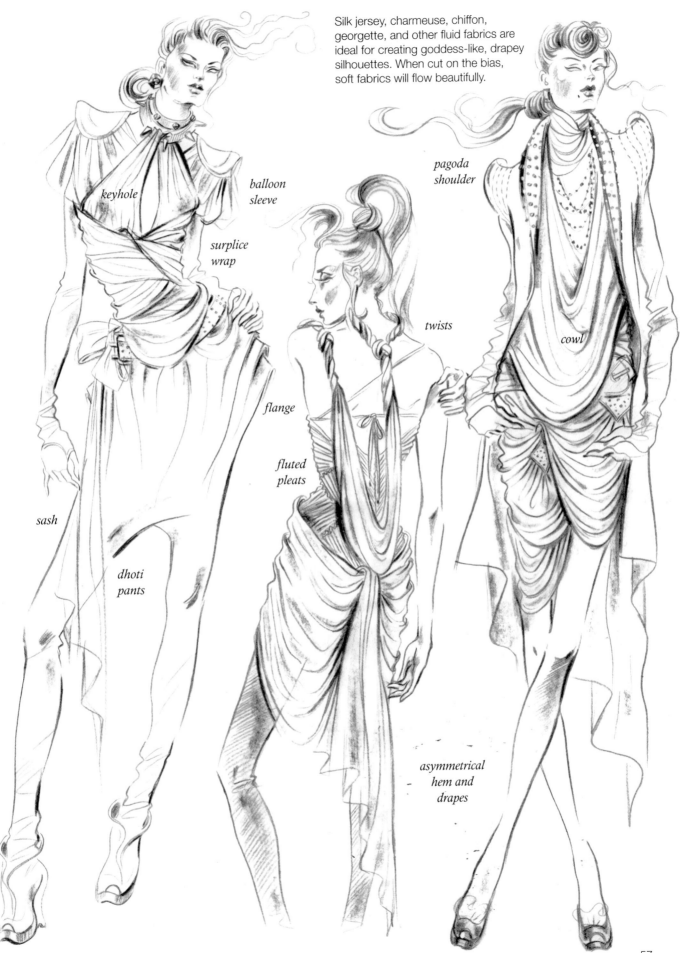

Silk jersey, charmeuse, chiffon, georgette, and other fluid fabrics are ideal for creating goddess-like, drapey silhouettes. When cut on the bias, soft fabrics will flow beautifully.

keyhole

balloon sleeve

surplice wrap

pagoda shoulder

twists

cowl

flange

fluted pleats

sash

dhoti pants

asymmetrical hem and drapes

Fashion Flats

Active/Sport

The flat sketch is a precise technical representation of a garment. Freehand flats are also known in the industry as "floats" and can be illustrated with more movement and dimension. Extremely detailed and accurate flats are used in all sectors of the fashion industry for design, presentation, production, and marketing.

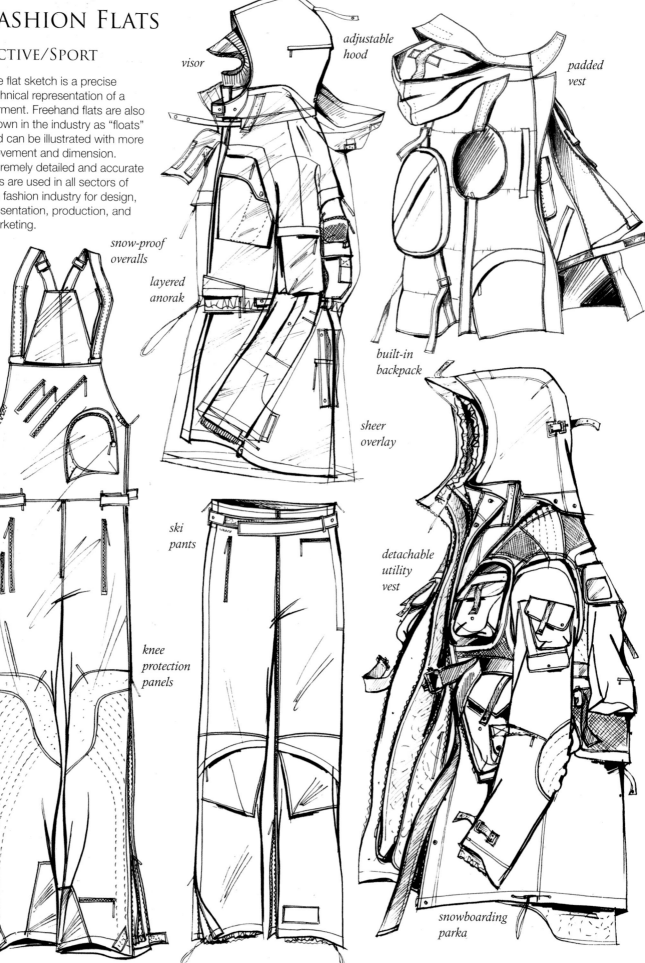

visor

adjustable hood

padded vest

snow-proof overalls

layered anorak

built-in backpack

sheer overlay

ski pants

detachable utility vest

knee protection panels

snowboarding parka

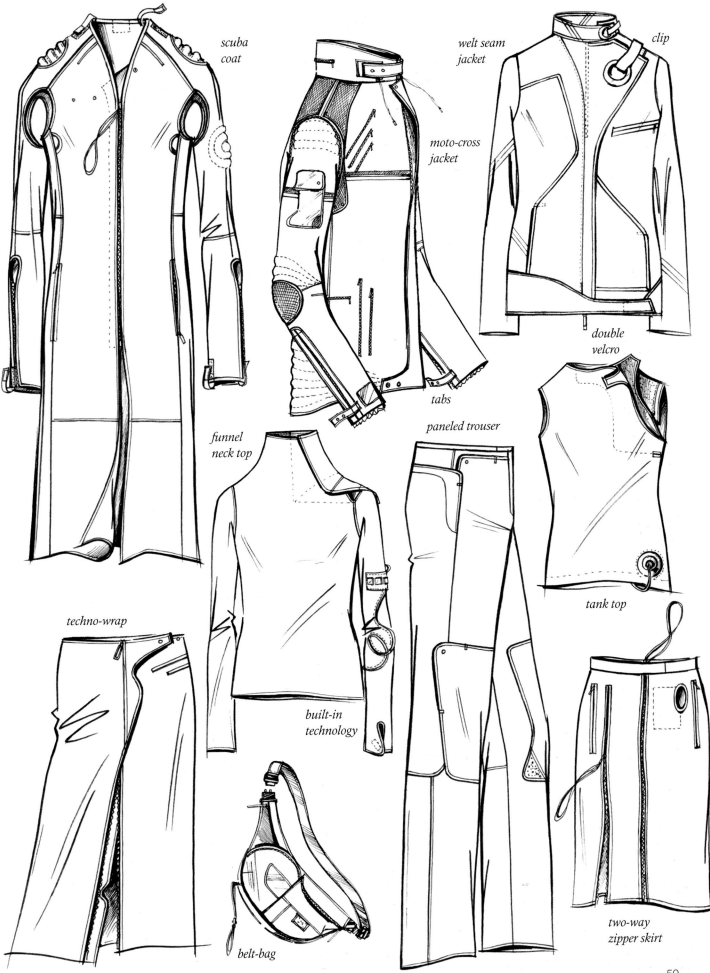

scuba
coat

welt seam
jacket

clip

moto-cross
jacket

double
velcro

tabs

funnel
neck top

paneled trouser

techno-wrap

tank top

built-in
technology

two-way
zipper skirt

belt-bag

59

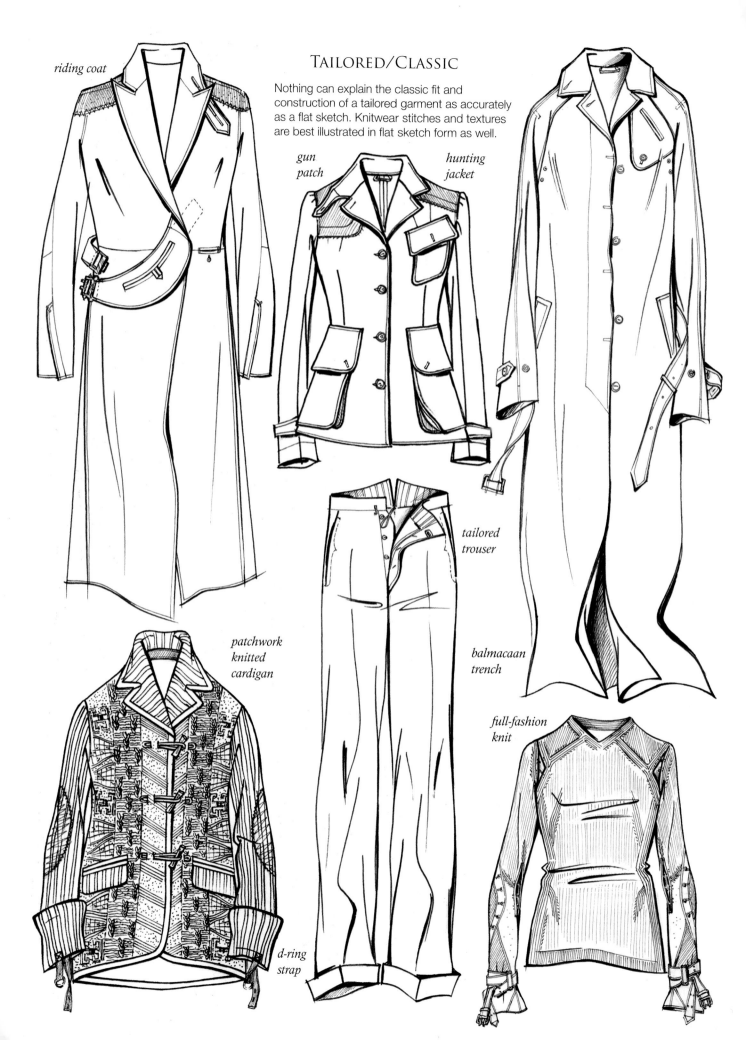

riding coat

TAILORED/CLASSIC

Nothing can explain the classic fit and
construction of a tailored garment as accurately
as a flat sketch. Knitwear stitches and textures
are best illustrated in flat sketch form as well.

gun
patch

hunting
jacket

tailored
trouser

patchwork
knitted
cardigan

balmacaan
trench

full-fashion
knit

d-ring
strap

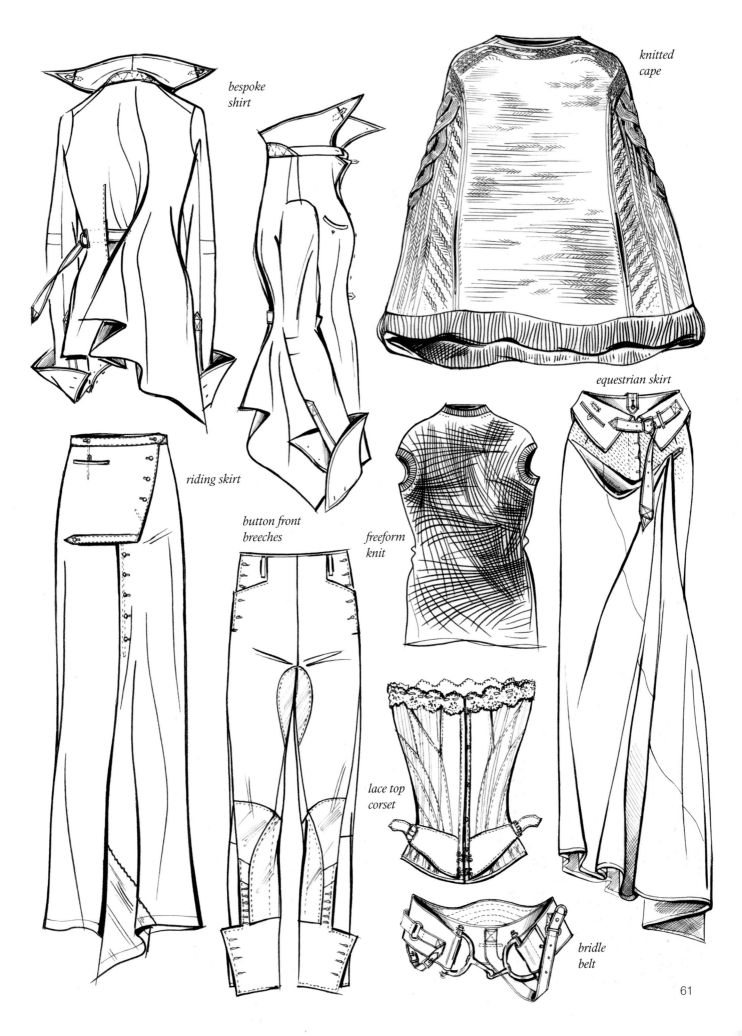

bespoke
shirt

knitted
cape

equestrian skirt

riding skirt

button front
breeches

freeform
knit

lace top
corset

bridle
belt

61

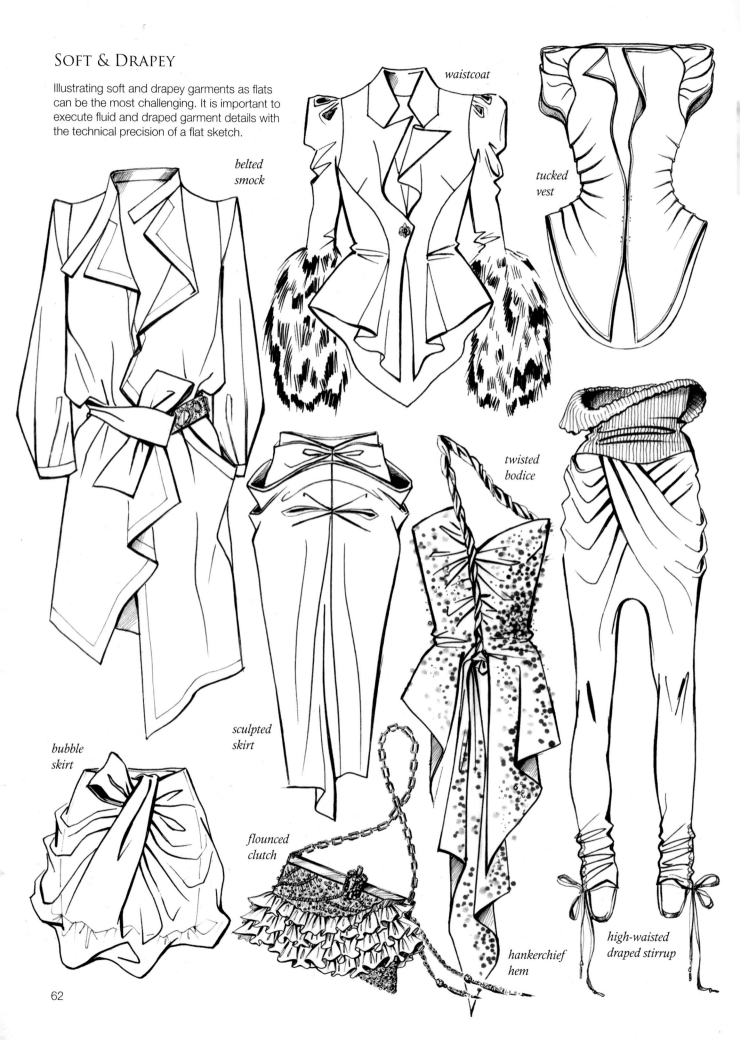

SOFT & DRAPEY

Illustrating soft and drapey garments as flats
can be the most challenging. It is important to
execute fluid and draped garment details with
the technical precision of a flat sketch.

waistcoat

belted smock

tucked vest

twisted bodice

bubble skirt

sculpted skirt

flounced clutch

hankerchief hem

high-waisted draped stirrup

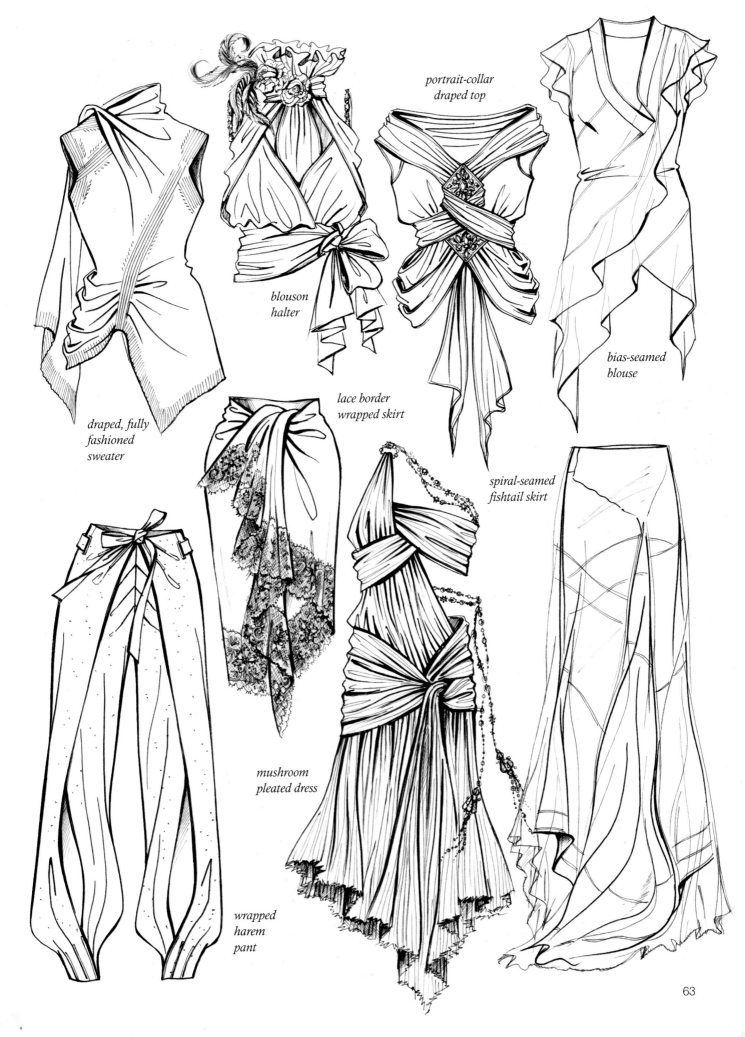

portrait-collar
draped top

blouson
halter

bias-seamed
blouse

draped, fully
fashioned
sweater

lace border
wrapped skirt

spiral-seamed
fishtail skirt

mushroom
pleated dress

wrapped
harem
pant

63

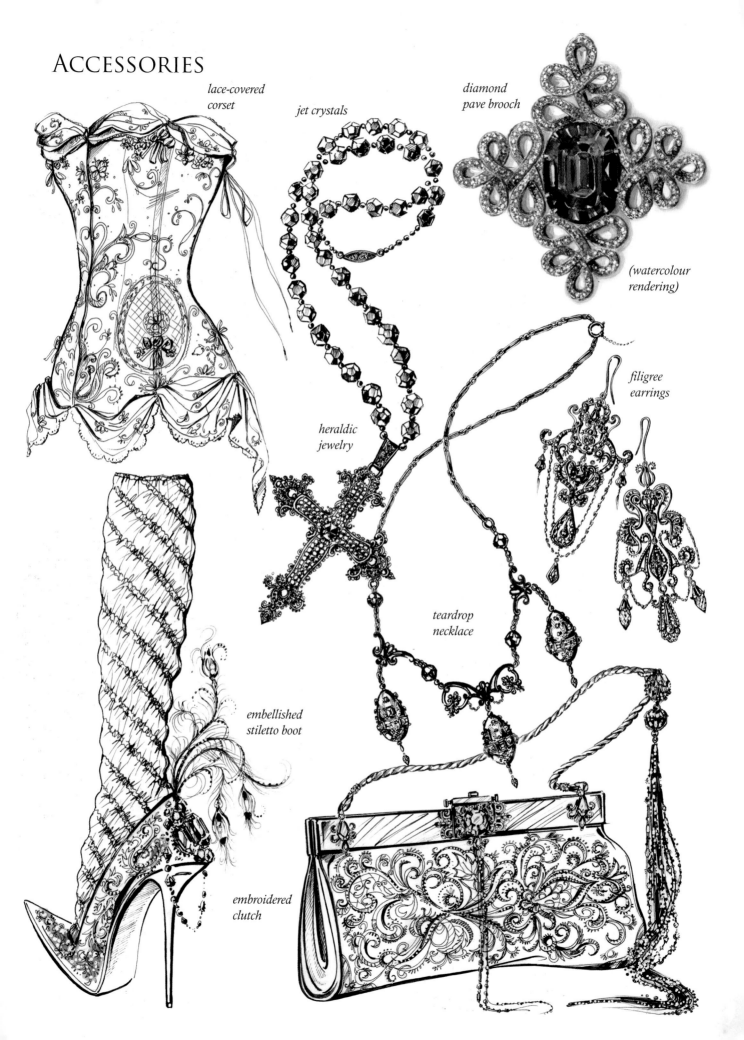

ACCESSORIES

lace-covered
corset

jet crystals

diamond
pave brooch

(watercolour
rendering)

filigree
earrings

heraldic
jewelry

teardrop
necklace

embellished
stiletto boot

embroidered
clutch

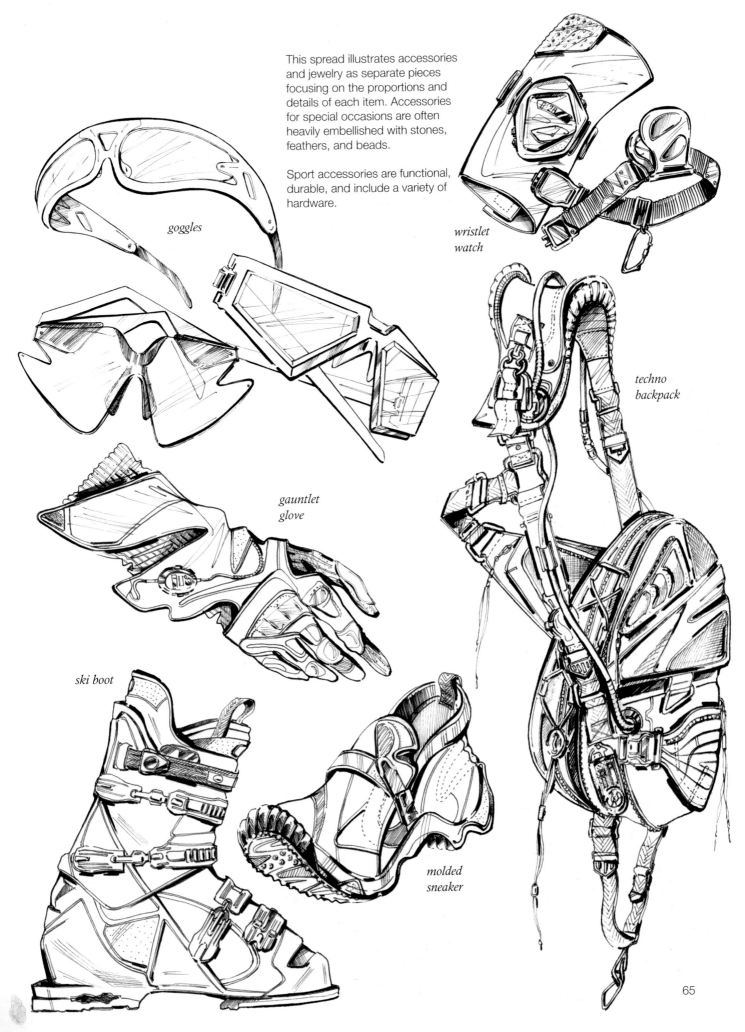

This spread illustrates accessories and jewelry as separate pieces focusing on the proportions and details of each item. Accessories for special occasions are often heavily embellished with stones, feathers, and beads.

Sport accessories are functional, durable, and include a variety of hardware.

goggles

wristlet watch

techno backpack

gauntlet glove

ski boot

molded sneaker

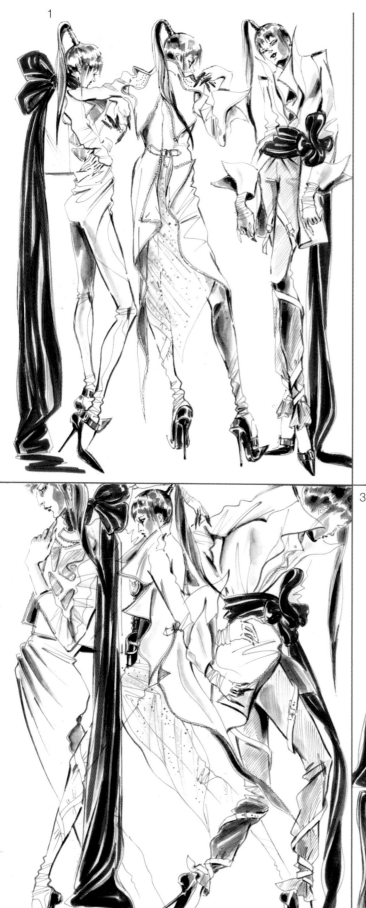

PAGE COMPOSITION

LAYOUT VARIATIONS

There are a few simple elements to a balanced layout. The proportion, volume, and silhouettes of the figures should create a visually compelling positive space (occupied by the image) and negative space (surrounding the image).

Coloured accents rhythmically placed throughout the page add balance and energy. It is crucial to experiment with a variety of page compositions in order to achieve the strongest presentation.

This spread illustrates different layout approaches using the same figures with the same outfits:

1. The rotated figures present each outfit from the most flattering viewpoint.

2. The cropped, dynamic figures create an electrifying and spontaneous mood.

3. The blocked layout offers a chance to zoom in on the most important design elements of the composition.

4. The simplest front-view composition can often be the most successful one, as demonstrated on the opposite page, as long as the composition creates visual impact.

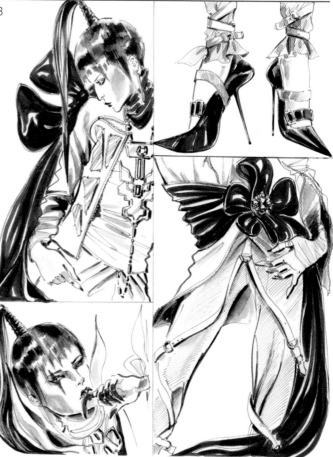

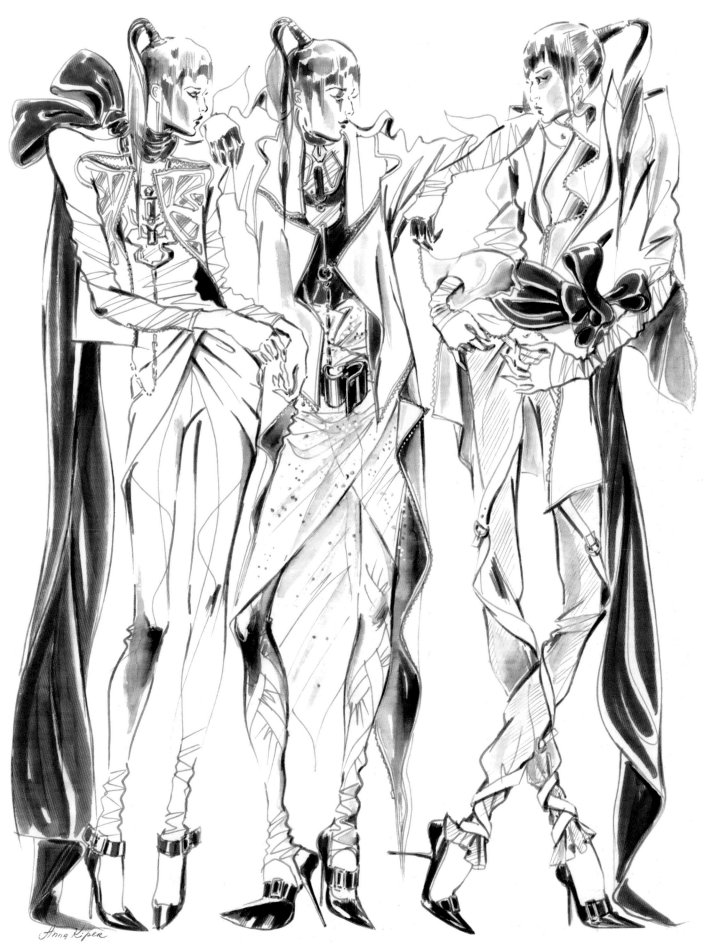

Anna Kiper

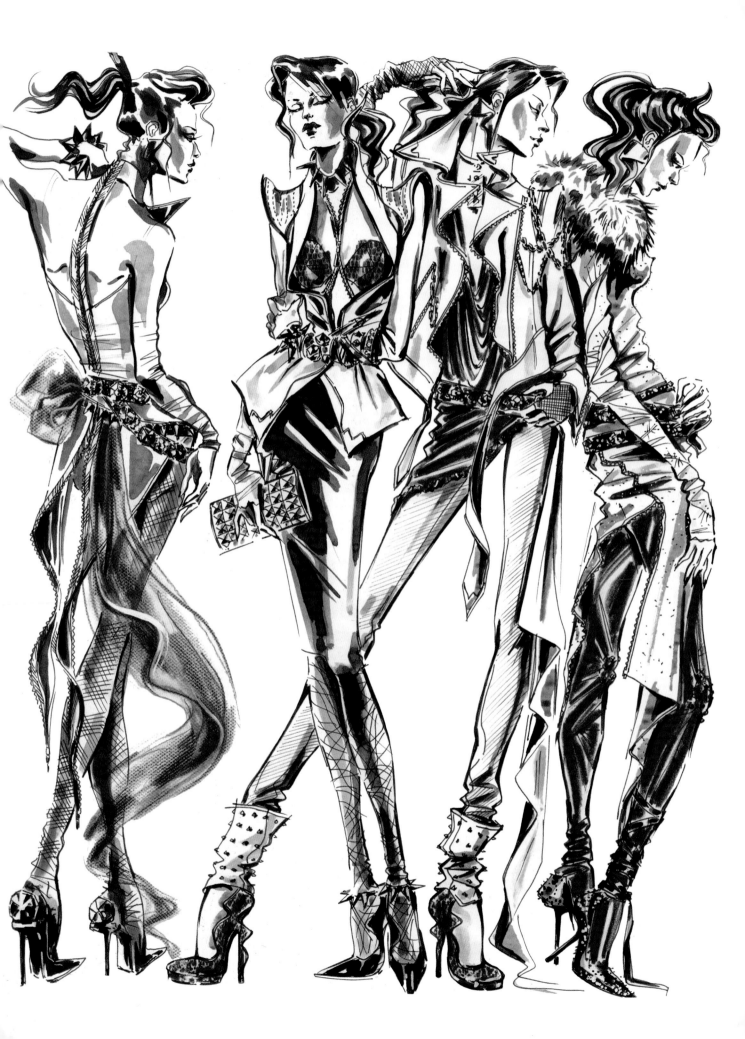

Grouping figures is a modern and stylish way to compose the page. This approach was often used by the famous illustrator Antonio Lopez in the 60s and 70s, and has now been revived by contemporary photographers in fashion editorials.

Anna Kiper

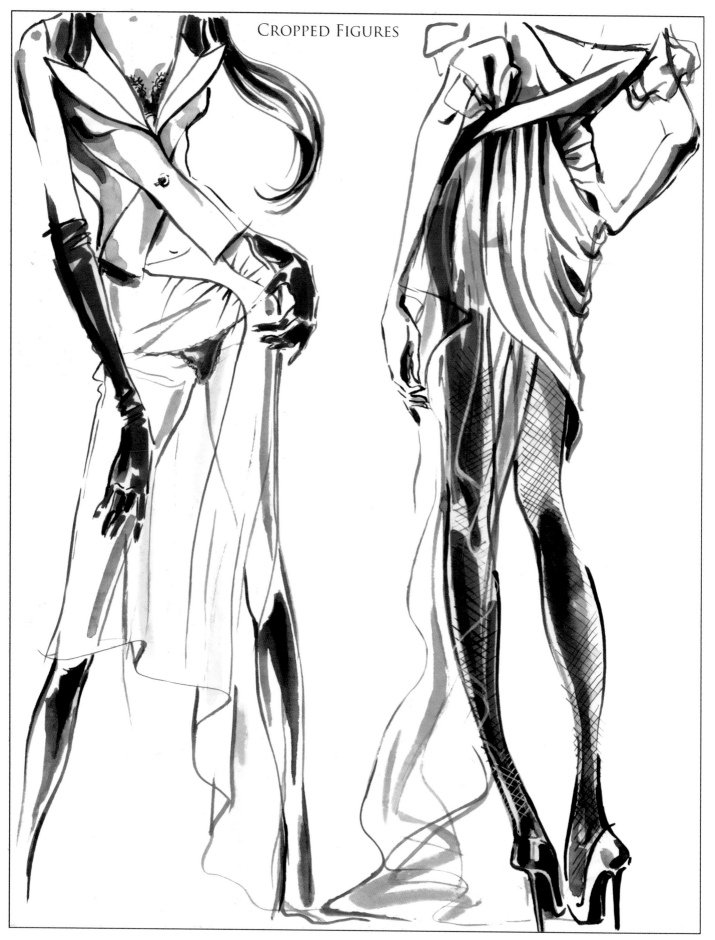

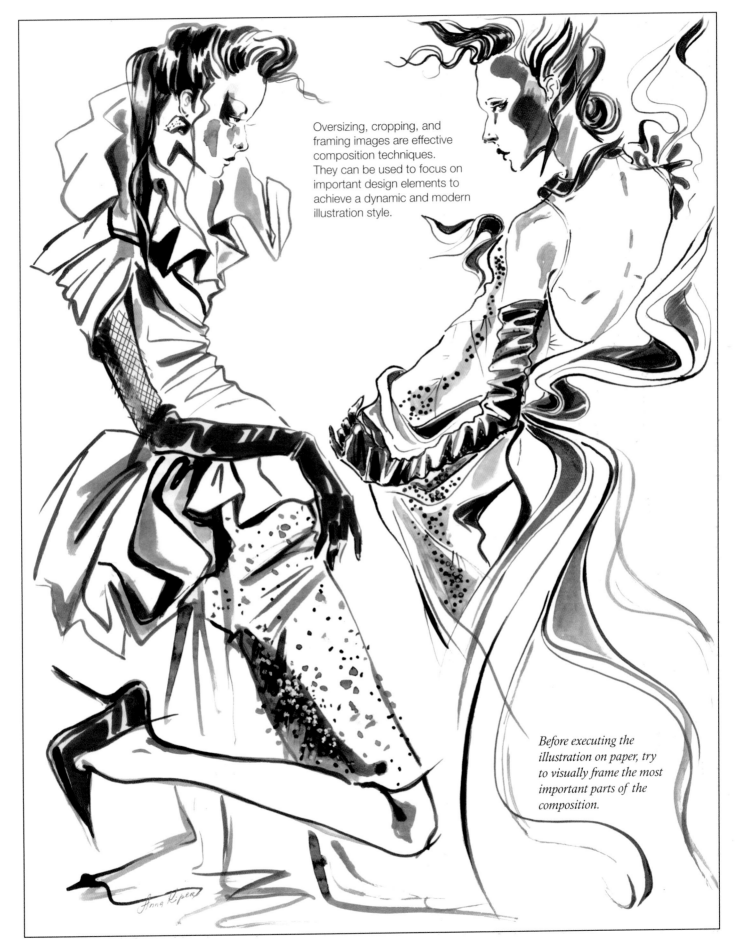

Oversizing, cropping, and framing images are effective composition techniques. They can be used to focus on important design elements to achieve a dynamic and modern illustration style.

Before executing the illustration on paper, try to visually frame the most important parts of the composition.

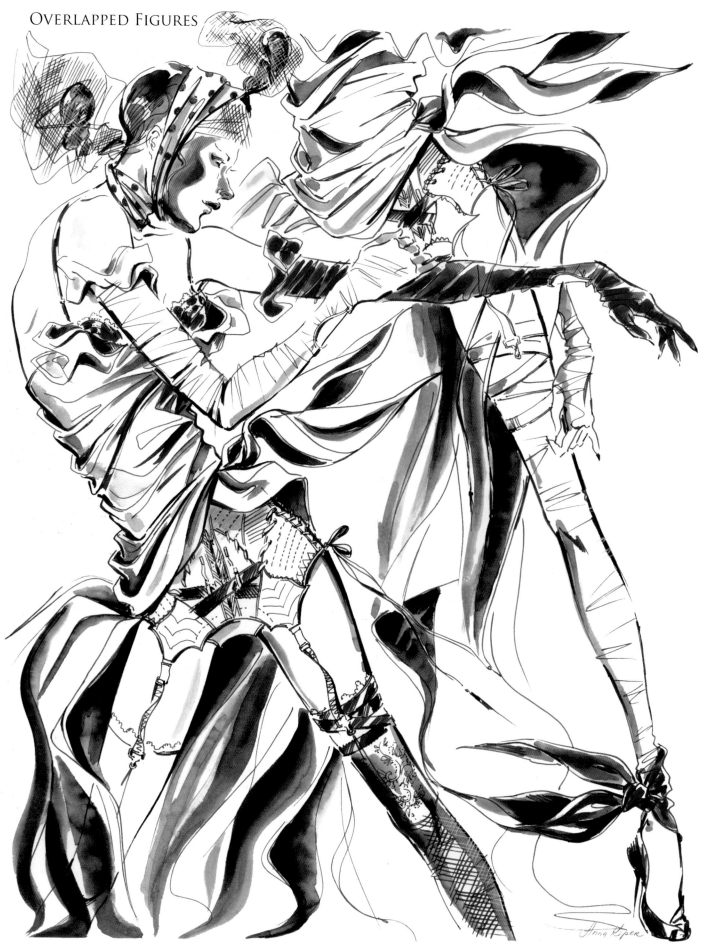

Exaggeration is essential in fashion illustration. Overlapping figures can create dramatic compositions. Dynamic silhouettes will practically touch all four corners of the page, filling the entire space.

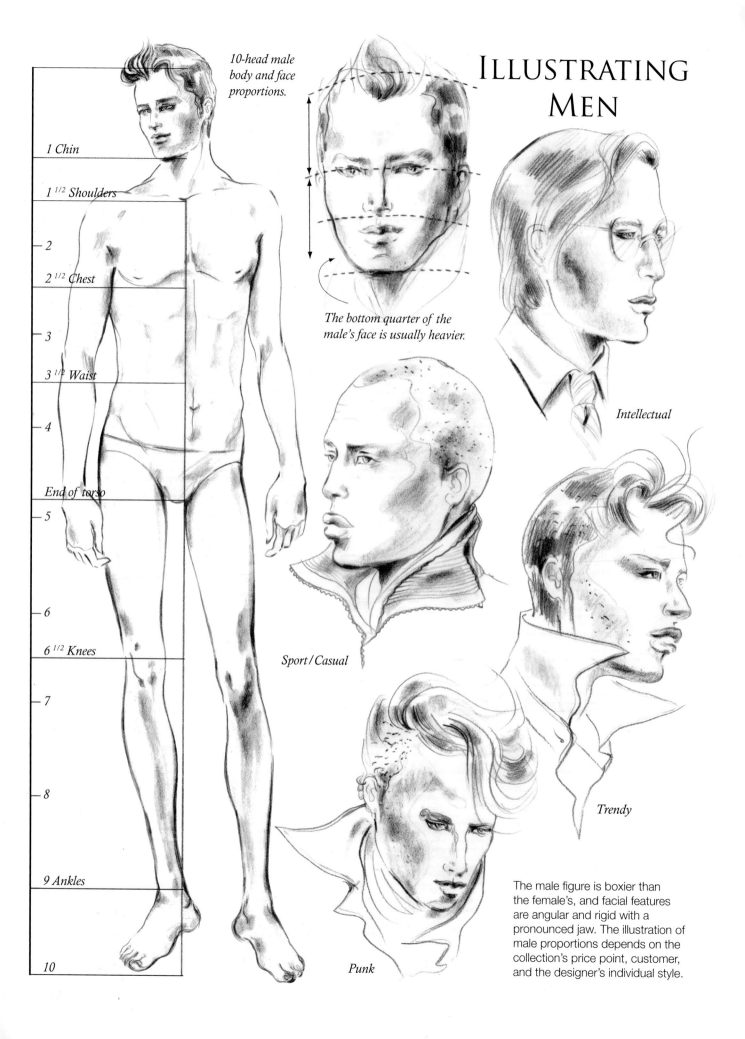

1 Chin

1 1/2 Shoulders

2

2 1/2 Chest

3

3 1/2 Waist

4

End of torso

5

6

6 1/2 Knees

7

8

9 Ankles

10

10-head male body and face proportions.

The bottom quarter of the male's face is usually heavier.

ILLUSTRATING MEN

Intellectual

Sport / Casual

Trendy

Punk

The male figure is boxier than the female's, and facial features are angular and rigid with a pronounced jaw. The illustration of male proportions depends on the collection's price point, customer, and the designer's individual style.

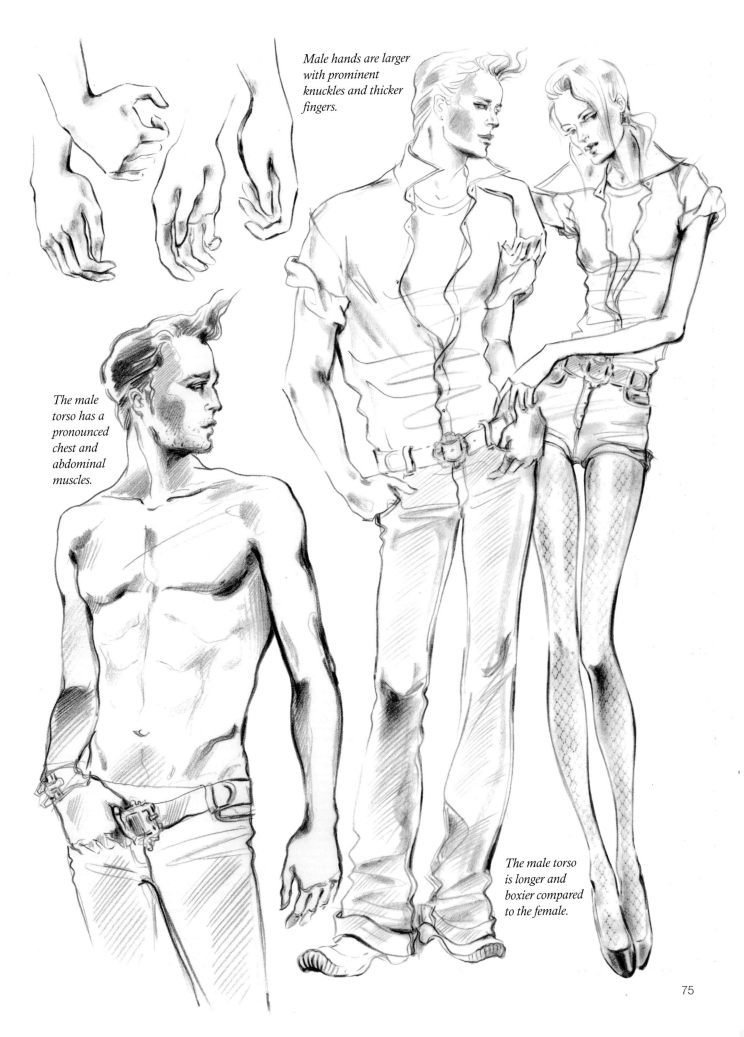

Male hands are larger
with prominent
knuckles and thicker
fingers.

The male
torso has a
pronounced
chest and
abdominal
muscles.

The male torso
is longer and
boxier compared
to the female.

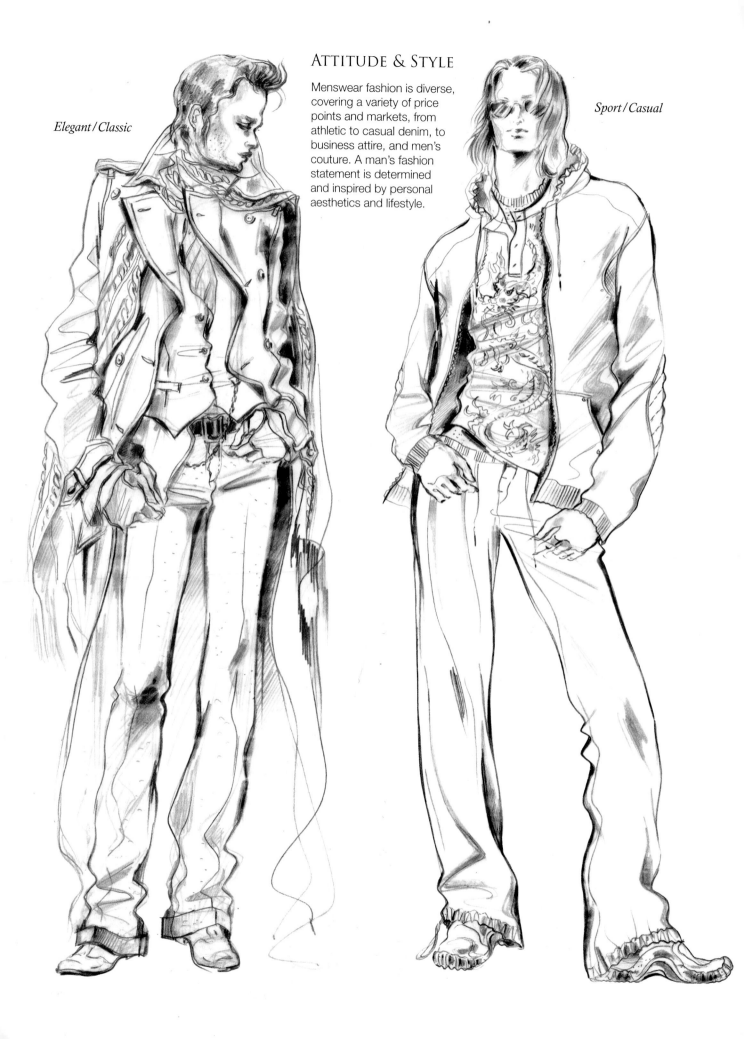

Elegant / Classic

ATTITUDE & STYLE

Menswear fashion is diverse, covering a variety of price points and markets, from athletic to casual denim, to business attire, and men's couture. A man's fashion statement is determined and inspired by personal aesthetics and lifestyle.

Sport / Casual

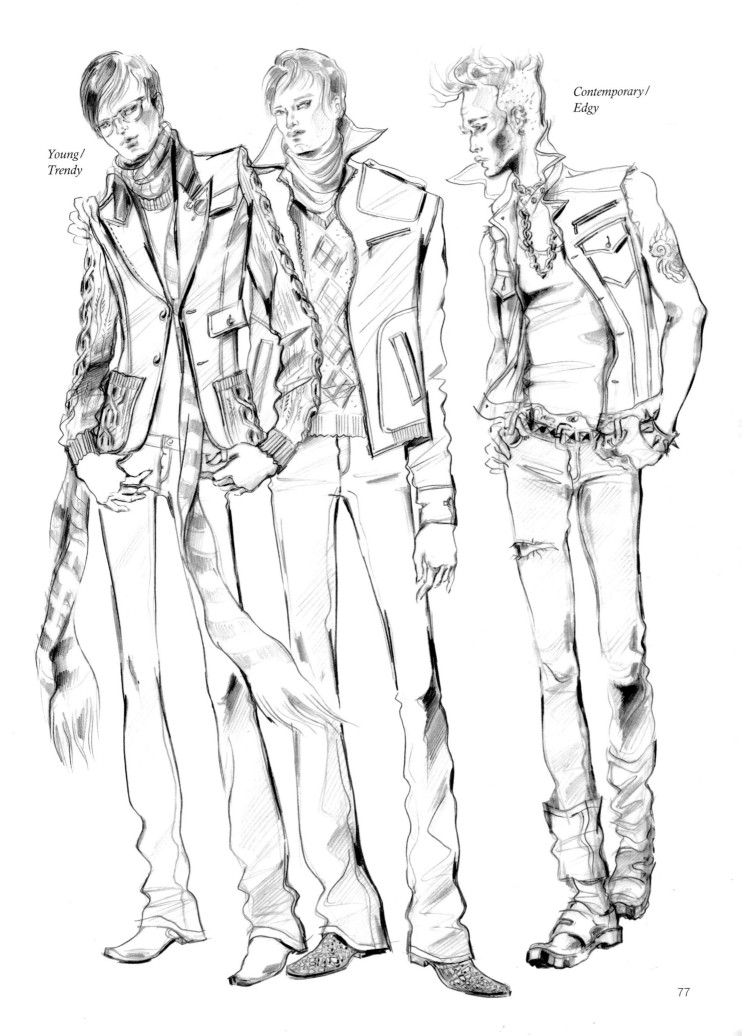

Young/
Trendy

Contemporary/
Edgy

MENSWEAR BASICS

Menswear is less complicated than women's wear. Silhouettes are usually classically cut and simplified. Garment details, fabrications, and hardware tend to be more prominent and often become a strong focal point in a trendy sportswear market. Menswear garments are closed left over right on the body.

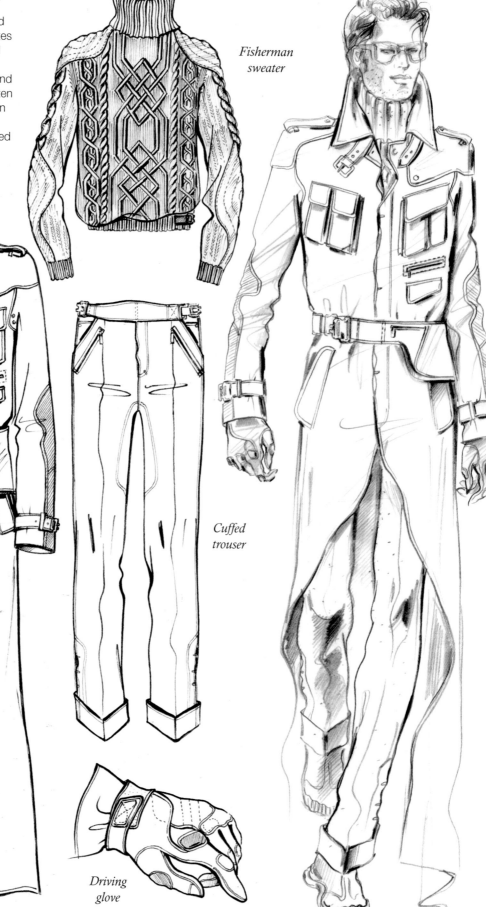

Fisherman sweater

Trench coat

Cuffed trouser

Driving glove

To illustrate menswear, base colours are applied on top of detailed pencil drawings, leaving a few highlights. Textures and patterns are rendered next. Shadows should be emphasized for a more dramatic effect.

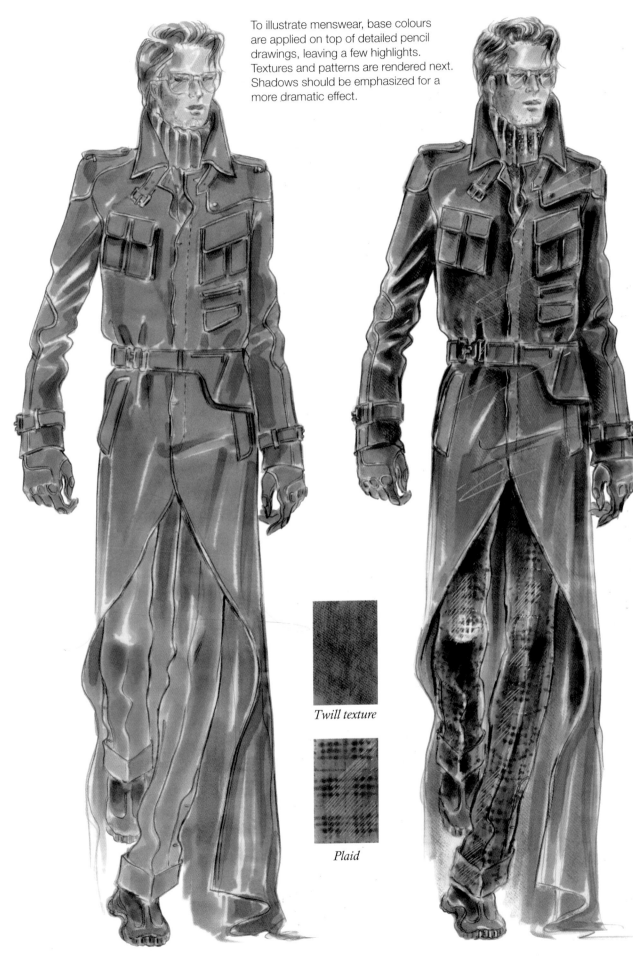

Twill texture

Plaid

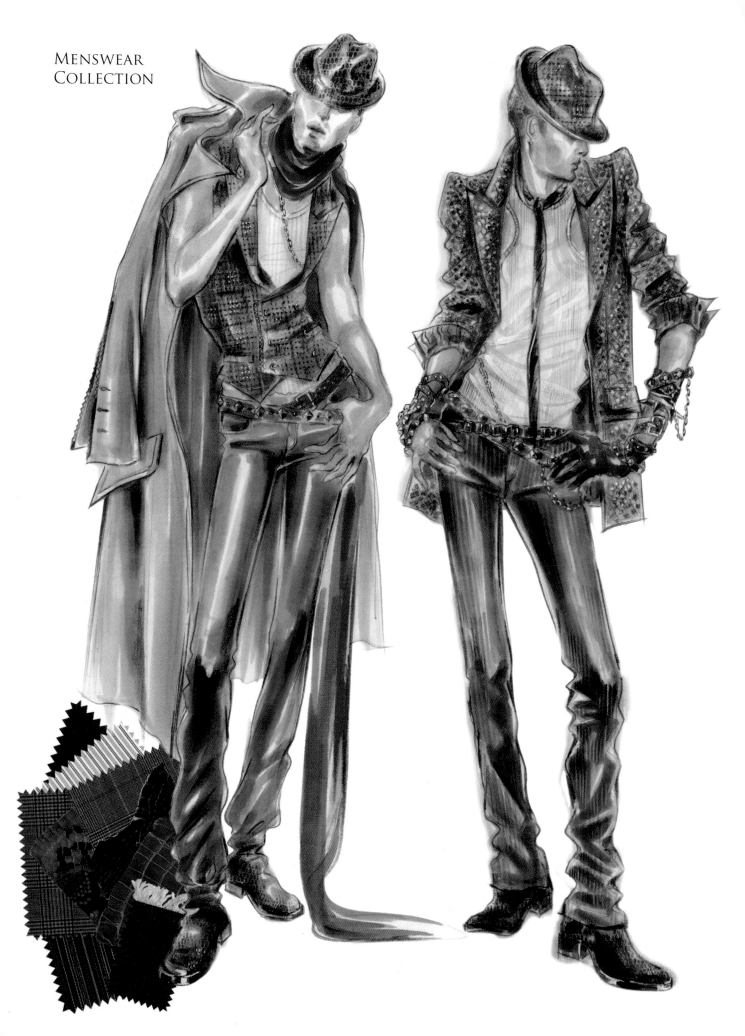

While the design concept influences the illustration's mood, the model's attitude and posture is essential for their visual impact. The use of bright coloured accents throughout the layout can create focal points on each figure and connect the entire composition.

QUICK SKETCHING

Balance, perspective, and other fundamental principles of female model drawing also apply to drawing the male figure.

The play of light and shadow, line quality, intensity of colour and texture can bring a brief spontaneous gesture to life.

Coloured pencils on clear velum

Quick marker blocking

Understanding the male form and its proportions is essential for creating a basic menswear illustration. However, to create an edgy, stylized drawing, proportions and body attitude should be exaggerated.

Anna Kiper

Illustrating Children

Drawing kids is a fun but challenging task. Their facial expressions can be sweet, naive, and mischievous, all at the same time. Their poses are animated and expressive. Children's proportions change rapidly as they grow. A child's body is measured in head lengths, just as an adult's body. For example, a one-year old child is only four heads tall while a seven-year old child measures six heads tall. Unstable toddlers often spread their arms and legs in cute but awkward poses.

Young children have big foreheads and their facial features are placed on the lower third part of the head.

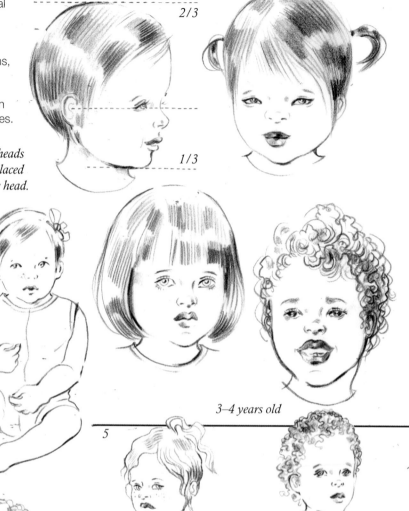

Infants

Young children have big foreheads and their facial features are placed on the lower third part of the head.

3–4 years old

1–2 years old

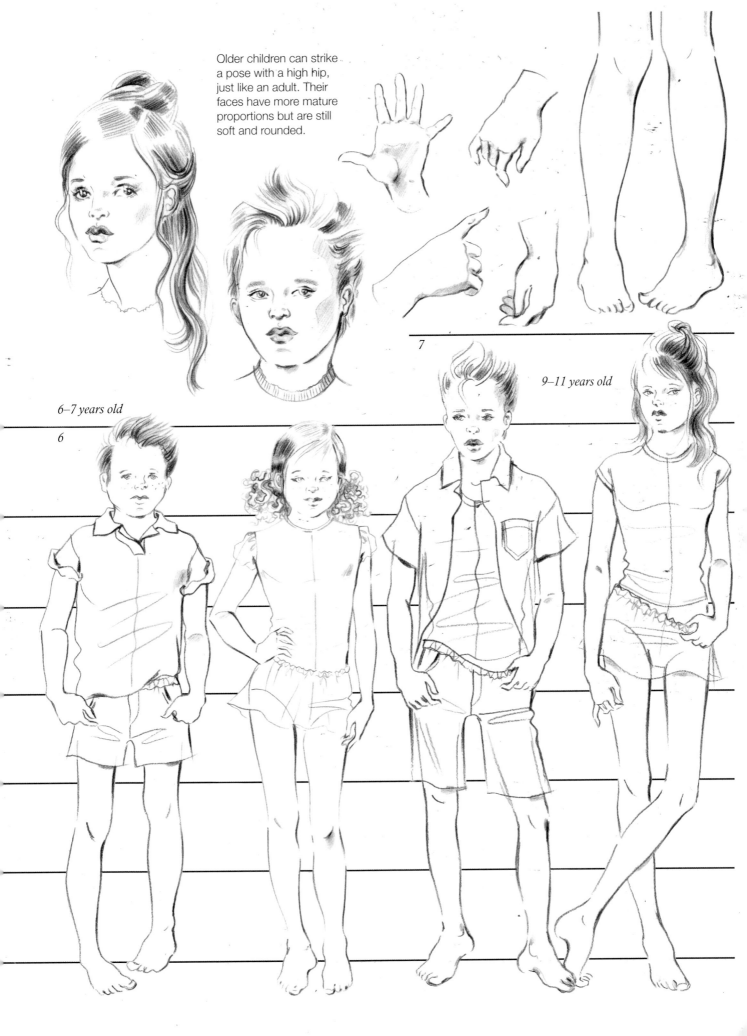

Older children can strike a pose with a high hip, just like an adult. Their faces have more mature proportions but are still soft and rounded.

7

9–11 years old

6–7 years old

6

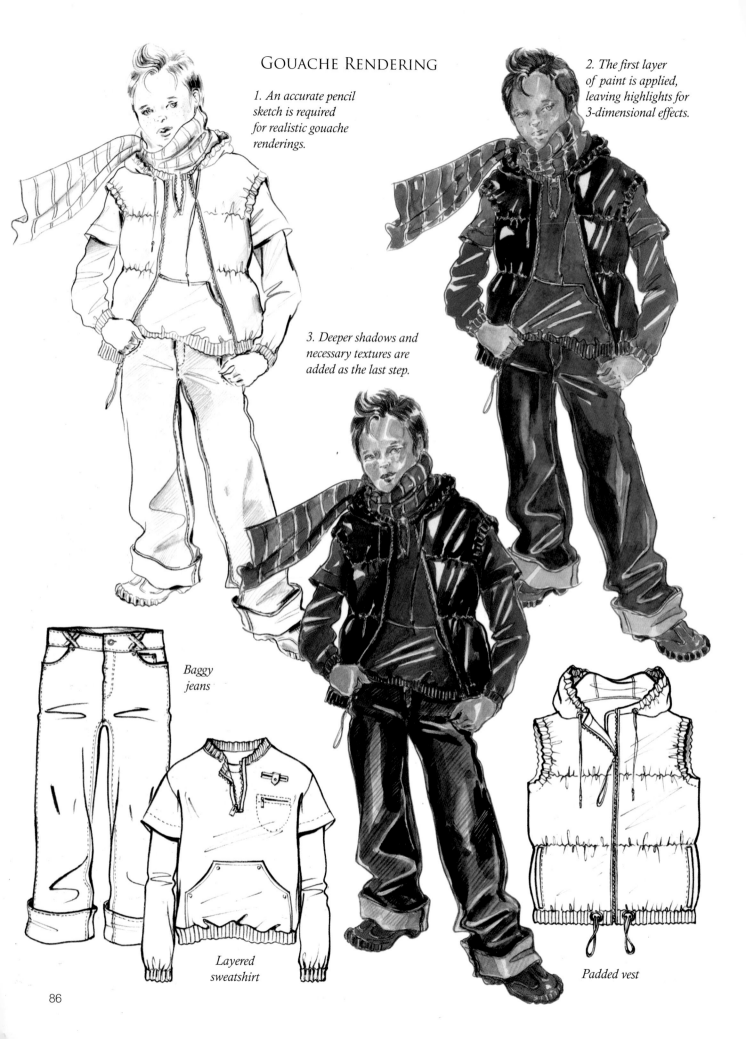

GOUACHE RENDERING

1. An accurate pencil sketch is required for realistic gouache renderings.

2. The first layer of paint is applied, leaving highlights for 3-dimensional effects.

3. Deeper shadows and necessary textures are added as the last step.

Baggy jeans

Layered sweatshirt

Padded vest

MARKER RENDERING
TRACING METHOD

1. A clean sheet of marker paper should be placed on top of the detailed pencil drawing. Since marker paper is semi-translucent, the outline of the drawing will show through.

2. Following the drawing underneath, complete the marker rendering, leaving highlights and adding shadows.

3. Restore the missing outline precisely by tracing it from the layer underneath. Add accents and textures.

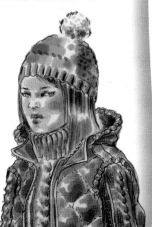

Quilted vest

Cable sweater

Denim A-line skirt

Children's flats should be in proportion to the age category. Remember children's clothes should be comfortable, functional, and colourful.

CHILDREN'S WEAR

Children's wear collections are often inspired by a particular theme, which influences styles, colours, prints, and graphics.

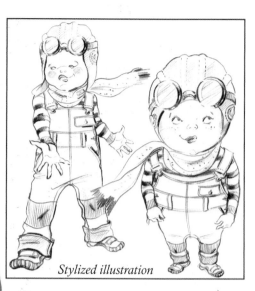

Stylized illustration

Extreme perspective and unusual view points can be helpful in creating stylized illustrations.

*Casual / Denim collection
Western influences*

For centuries, children's clothes were scaled-down versions of adult clothing, often restrictive and conservative. Today, children's wear is well-developed and specifically targeted to its customers. Children's wear is now innovative, creative, and colourful, integrating a mix of graphic motifs and textures.

89

FABRIC RENDERING
TECHNIQUES

The illustration of colourful, intricate patterns and motifs requires precision and special skills. The challenging part of print rendering is illustrating decorative elements with depth and dimension. Most printed fabrics are organized into repeated patterns. However, some prints are engineered in such a way that the motifs are limited to specific areas of a fabric to create borders and bleeding edges.

The figure's posture affects the
volume and movement of a fabric.
Print elements appear randomly
shifted and partially hidden in folds
and creases. Capturing the feel,
weight, and movement of fabric is
essential. Study the artwork of Erté,
Leon Bakst, Klimt, and other great
artists and costume illustrators for
inspiration in fabric rendering.

TEXTURES

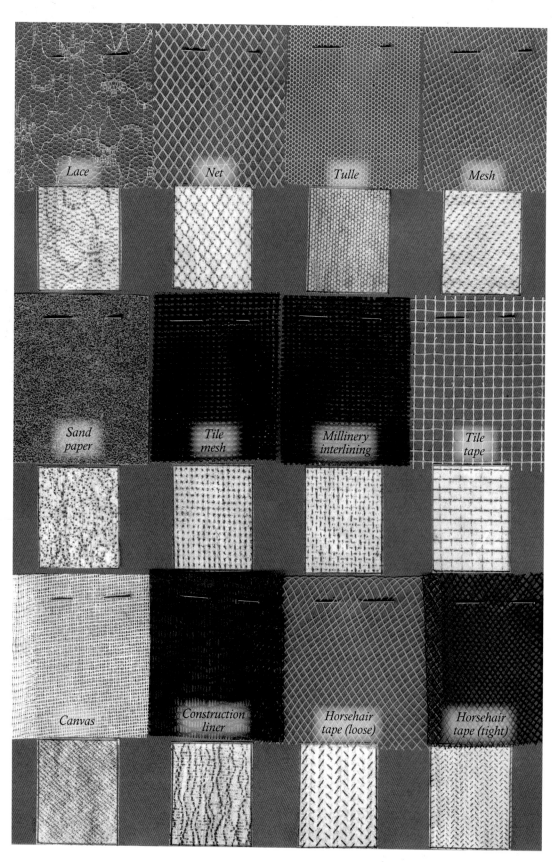

Lace

Net

Tulle

Mesh

Sand paper

Tile mesh

Millinery interlining

Tile tape

Canvas

Construction liner

Horsehair tape (loose)

Horsehair tape (tight)

High quality art supplies can stimulate and inspire but never substitute for creativity and skills.

MARKERS
It is not easy to identify the best single marker brand. Some markers appear brighter and more saturated, while others streak less, creating a smoother surface. Some markers have multiple tips for versatility. Frequently, a combination of several brands can produce the desired results.

PENCILS
In marker rendering, pencils are supplemental and often used on top of the marker surface for accents, textures, and outlines.

TEXTURES
To create interesting effects and textures, the edges of your pencil can be used to rub off dimensional surfaces placed underneath marker paper. For example, a tweed fabric effect can be achieved with sand paper or a herringbone wool with horsehair tape. See left for additional examples.

COLOURING SOLIDS
Every fold in every garment is a single shape. To express depth and dimension of the garment, shapes should be illustrated with a natural play of highlight, mid-tone, shadow, and reflection. This effect can be achieved by leaving white highlights and applying shades of one colour to create dimension.

SUPPLIES

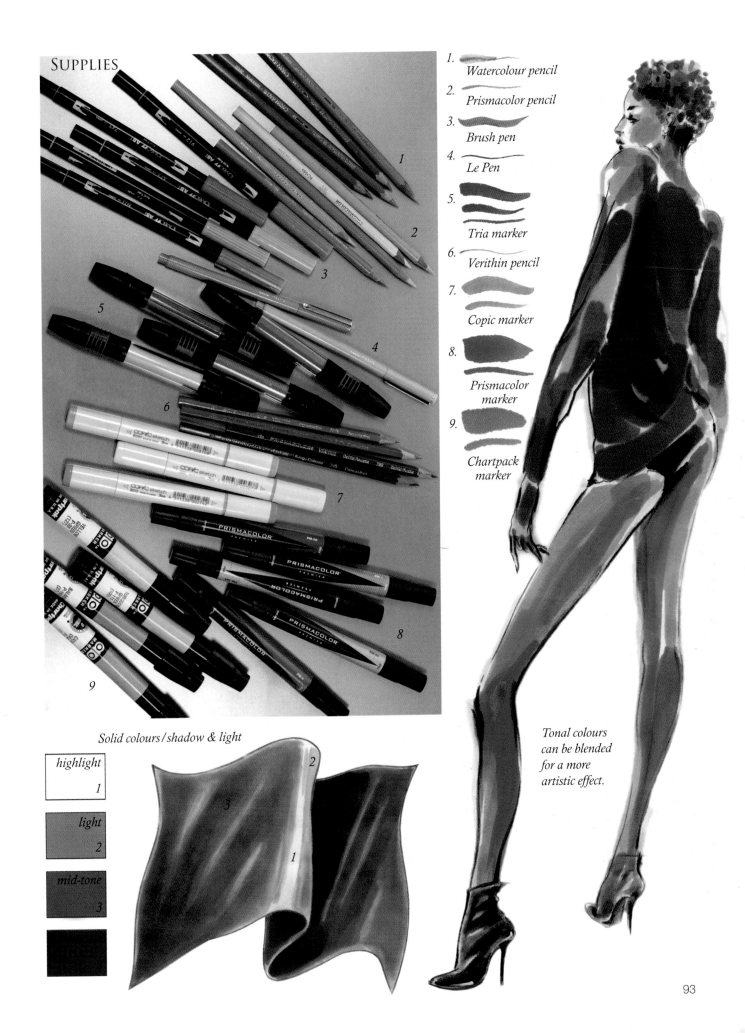

1. Watercolour pencil
2. Prismacolor pencil
3. Brush pen
4. Le Pen
5. Tria marker
6. Verithin pencil
7. Copic marker
8. Prismacolor marker
9. Chartpack marker

Tonal colours can be blended for a more artistic effect.

Solid colours / shadow & light

highlight	1
light	2
mid-tone	3

WOOLS

Wools are fluffy, soft, and textural. The outline of wool garments should look faded and washed out. Small cross-hatching, flakes, and doodles are excellent techniques for wool rendering. Brush pens, coloured pencils, dry brush and texture rub-off techniques are the best tools for illustrating wool.

Bouclé

Tweed

Twill plaid

Houndstooth

Marker rendering

Herringbone

Glen plaid

94

For plaids, curve the horizontal lines of the basic grid to follow the cylindrical shape of the human body. Vertical lines of the grid often appear shifted and broken, following the folds and creases of the garment. Use fine vertical lines for pinstripes and herringbone development.

Burberry plaid

Tweed / Herringbone

Pinstripe

Gouache rendering

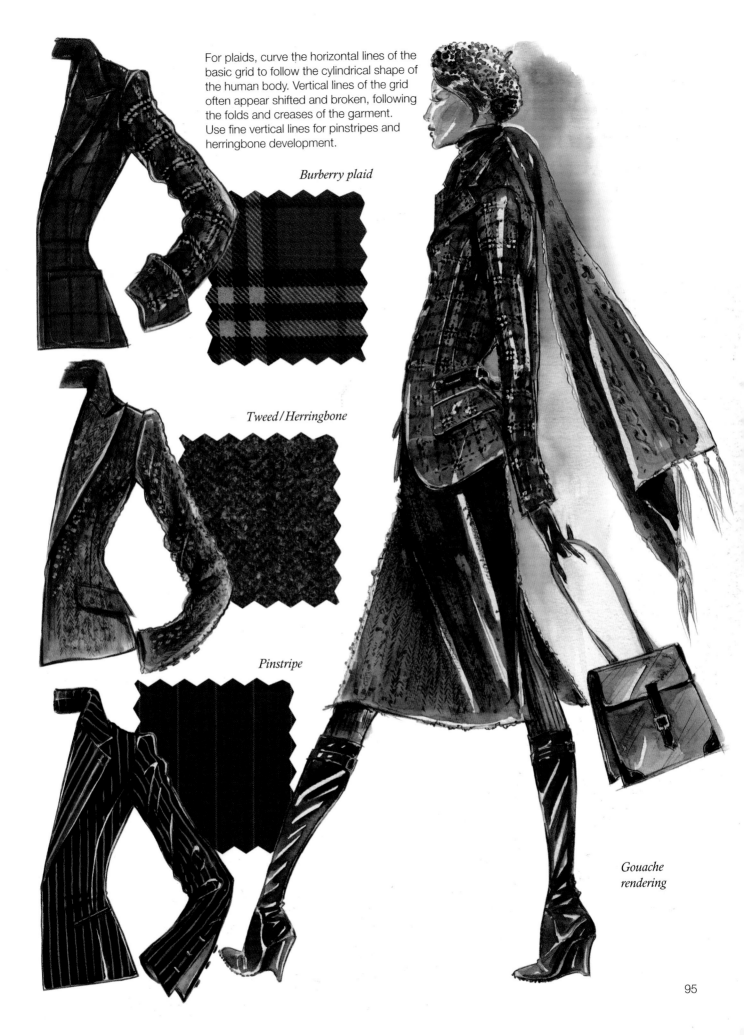

FURS & SKINS

Animal prints, fuzzy chevrons, speckled, and scaled surfaces are mostly laid out in regular rows and grids. A dry brush technique, brush pens, coloured pencils, and eye shadows are excellent tools for illustrating a variety of furs. Curly, wavy, and smudgy lines also illustrate fur effectively.

Mink

Zebra

Lizard

Anna Kiper

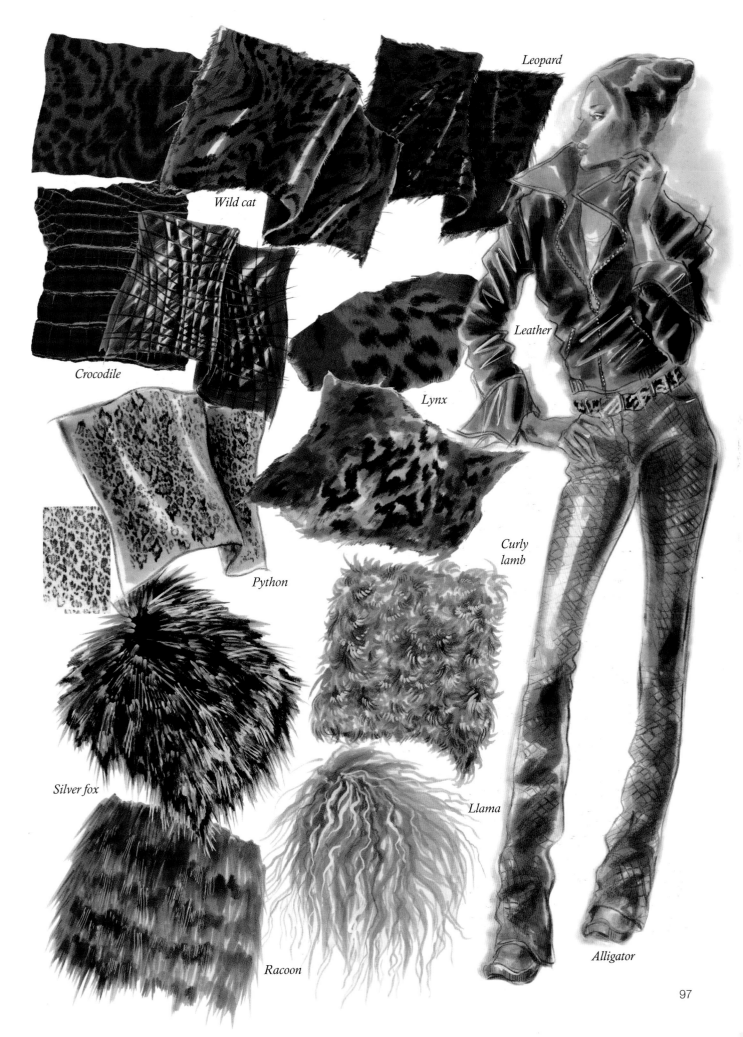

Leopard

Wild cat

Crocodile

Leather

Lynx

Python

Curly
lamb

Silver fox

Llama

Racoon

Alligator

97

DENIM/TWILL

Shades of blue-greys and indigo are typical choices for denim. Ground layers should be carefully applied avoiding seams and highlighting the distressed areas.

Use white pencil to show twill texture in the darker areas and indigo pencil over the highlights. Twill texture looks precise and realistic when rubbed off over a swatch of denim or a piece of cotton canvas.

Denim marker colours:

Cloud blue

Blue grey

Pale indigo

Brittany blue

Indigo blue

Prussian blue

Navy blue

Painted denim samples

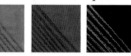

Gouache painted denim skirt

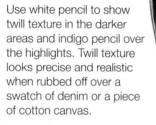
Indigo pencil over marker base

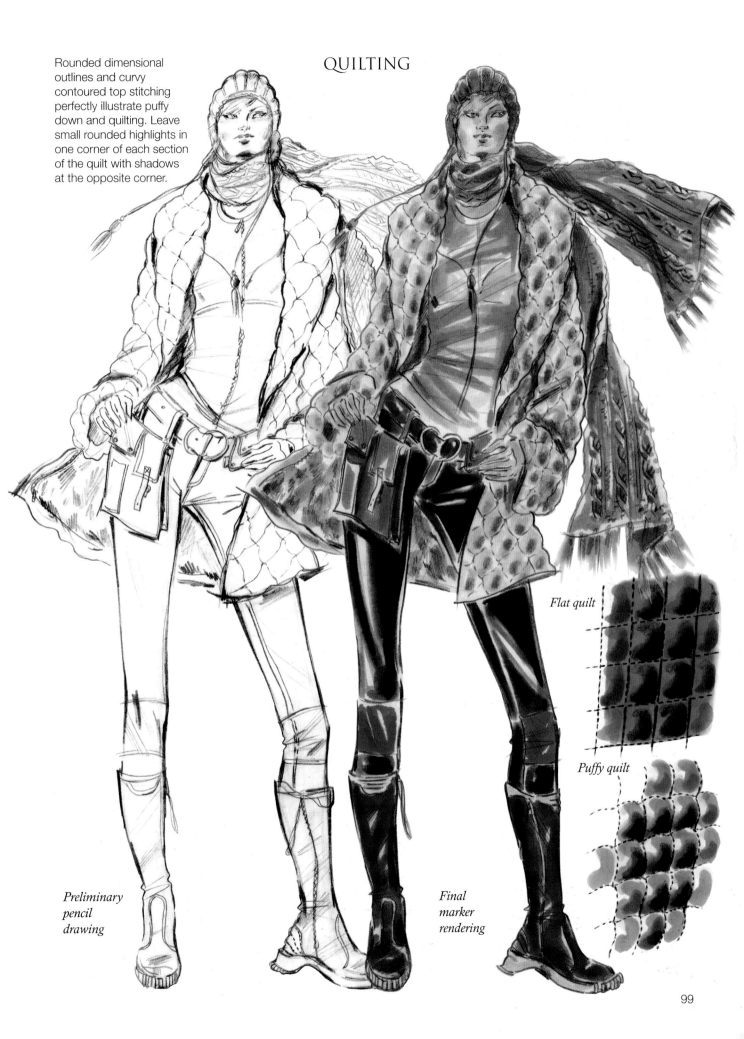

Rounded dimensional outlines and curvy contoured top stitching perfectly illustrate puffy down and quilting. Leave small rounded highlights in one corner of each section of the quilt with shadows at the opposite corner.

Preliminary pencil drawing

Final marker rendering

Flat quilt

Puffy quilt

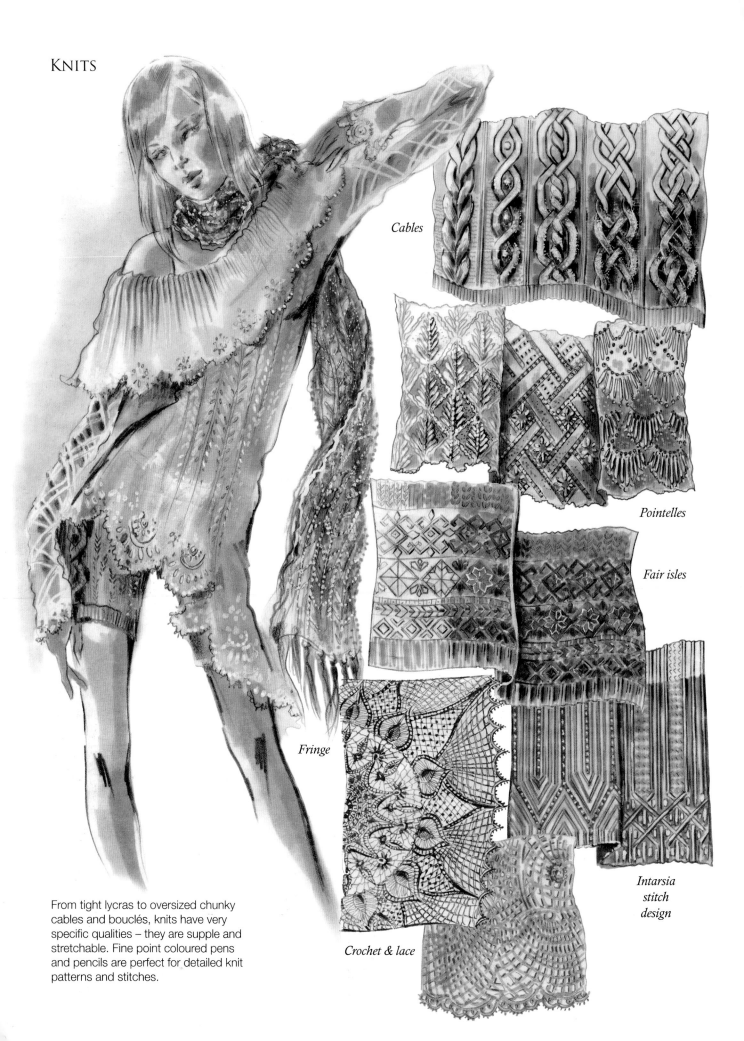

KNITS

Cables

Pointelles

Fair isles

Fringe

Intarsia
stitch
design

Crochet & lace

From tight lycras to oversized chunky
cables and bouclés, knits have very
specific qualities – they are supple and
stretchable. Fine point coloured pens
and pencils are perfect for detailed knit
patterns and stitches.

Soft surfaces created by fuzzy
yarns are better expressed with
brush pens, coloured pencils,
and smudgy pastels. Speckles,
flakes, curly loops, and wavy lines
will realistically convey the rich
texture and dimensional form of
knitwear stitches.

*Cable
collage*

Bouclé knit

*Lettuce
edge*

*Chunky
jersey*

Melange

*Textured
yarn*

SHINE & IRIDESCENCE

Most evening fabrics have smooth, lustrous, and glossy surfaces which reflect light beautifully. In order to express the luxurious shine of charmeuse, lamé, and taffeta, leave softer or sharper highlights.

Charmeuse

Duchess satin

Lamé

Velvet

Taffeta

White pencil will convey shimmer and soft reflections on velours and velvets. Iridesence can be expressed by blending two or more colours together.

Moiré

Velvet

Iridescent dupioni

Vinyl

SHEERNESS & TRANSPARENCY

Chiffons and georgettes are sheer, drapey, and fluid. Areas covered by the sheer fabric appear light and muted.

Sheers rendered by colouring from the back of the page.

Delicate smudges of coloured pencil realistically represent sheerness. Smearing pencil with blender marker will increase the effect.

Pencil over skin tone *Blender over pencil*

Printed georgette

Chiffon

Sharp, broken, edgy outlines represent crisp organza, organdy, and gazar. Loose strokes of almost dry marker over skin tone create the look of transparency. The same effect can be achieved by colouring from the back of the page. A second layer of colour should be added to folds and creases, so they look darker and more opaque.

PRINTED CHIFFON

1. Partially and loosely render the areas covered by the sheer.

2. Lightly fill in the colour of the transparent layer.

Printed chiffon

3. Add hints of the print on the sheers as the last step.

Organza

Anna Kiper

Lace overlay

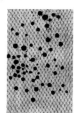

Point d'esprit

Point d'esprit overlay

Scalloped edge

Feathers

A dimensional edge can be added to tulle and netting with white out. Random dots, placed on fabric with a brush pen can represent point d'esprit.

Lace

Net

Lace, net, and tulle look especially dramatic layered over contrasting coloured undergarments. Use an actual piece of lace or tulle fabric to rub with pencils over undergarments, coming slightly outside of the shape for the overlay effect. Add fine tick marks to scalloped edges, and tighten the motif with additional elements.

Silk tulle

Anna Kiper

BEADS & SEQUINS

Glitter pens, metallic, and white-paint markers are the best tools to express the shine and highlights of beaded and sequined fabrics.

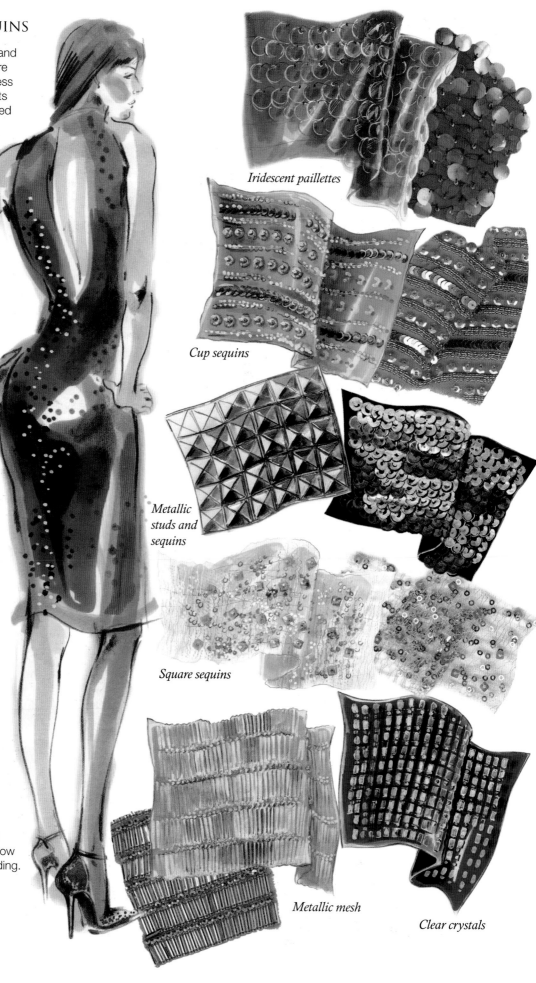

Iridescent paillettes

Cup sequins

Metallic studs and sequins

Square sequins

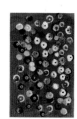

Coloured sequins

Seed beads

Black dots with shifted highlights effectively show the dimensions of beading.

Metallic mesh

Clear crystals

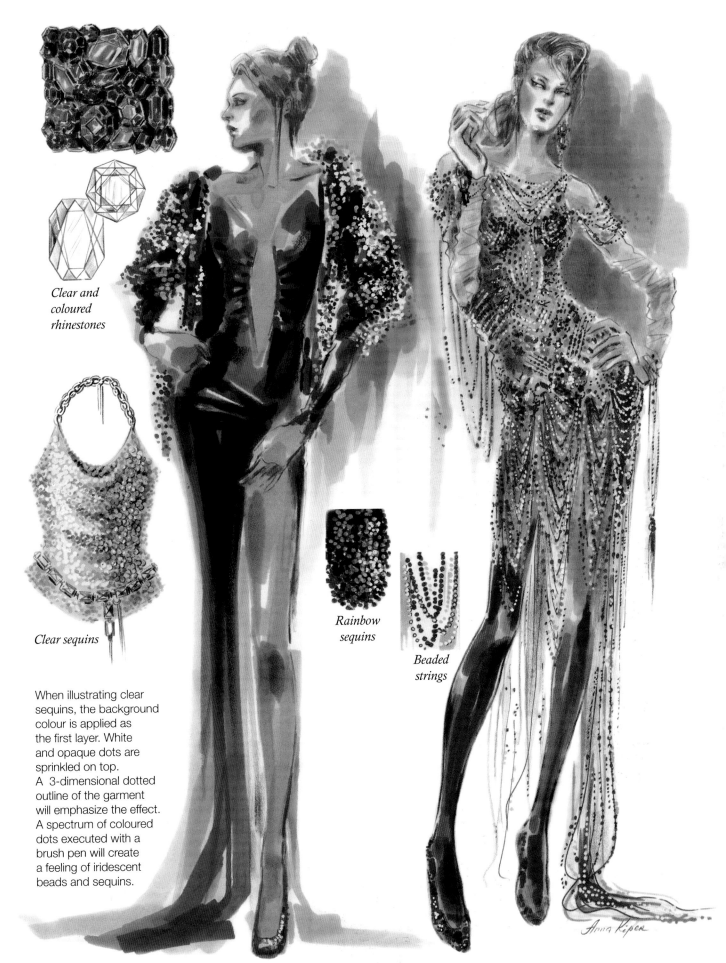

*Clear and
coloured
rhinestones*

Clear sequins

*Rainbow
sequins*

*Beaded
strings*

When illustrating clear
sequins, the background
colour is applied as
the first layer. White
and opaque dots are
sprinkled on top.
A 3-dimensional dotted
outline of the garment
will emphasize the effect.
A spectrum of coloured
dots executed with a
brush pen will create
a feeling of iridescent
beads and sequins.

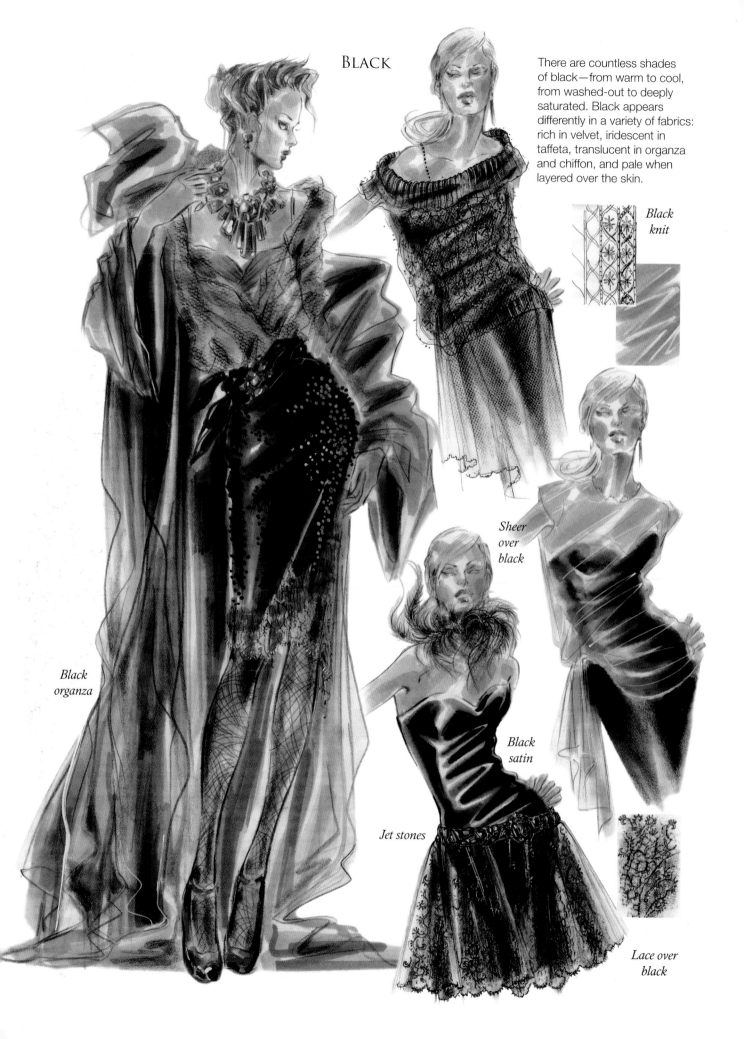

BLACK

There are countless shades of black—from warm to cool, from washed-out to deeply saturated. Black appears differently in a variety of fabrics: rich in velvet, iridescent in taffeta, translucent in organza and chiffon, and pale when layered over the skin.

Black knit

Sheer over black

Black organza

Black satin

Jet stones

Lace over black

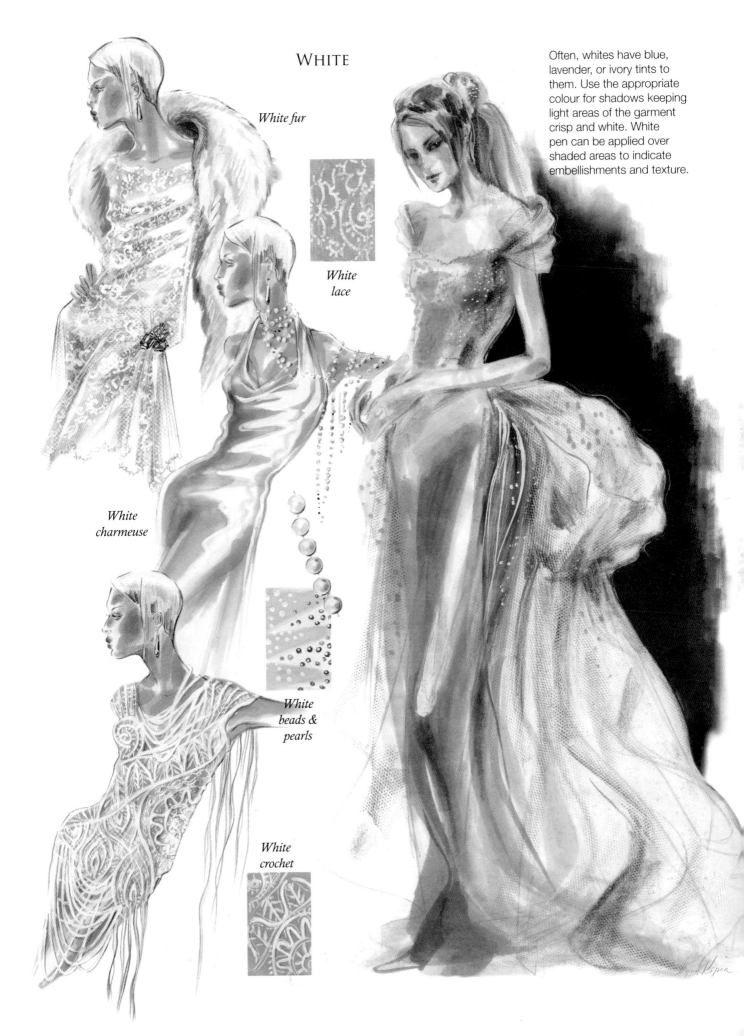

WHITE

White fur

White lace

White charmeuse

White beads & pearls

White crochet

Often, whites have blue, lavender, or ivory tints to them. Use the appropriate colour for shadows keeping light areas of the garment crisp and white. White pen can be applied over shaded areas to indicate embellishments and texture.

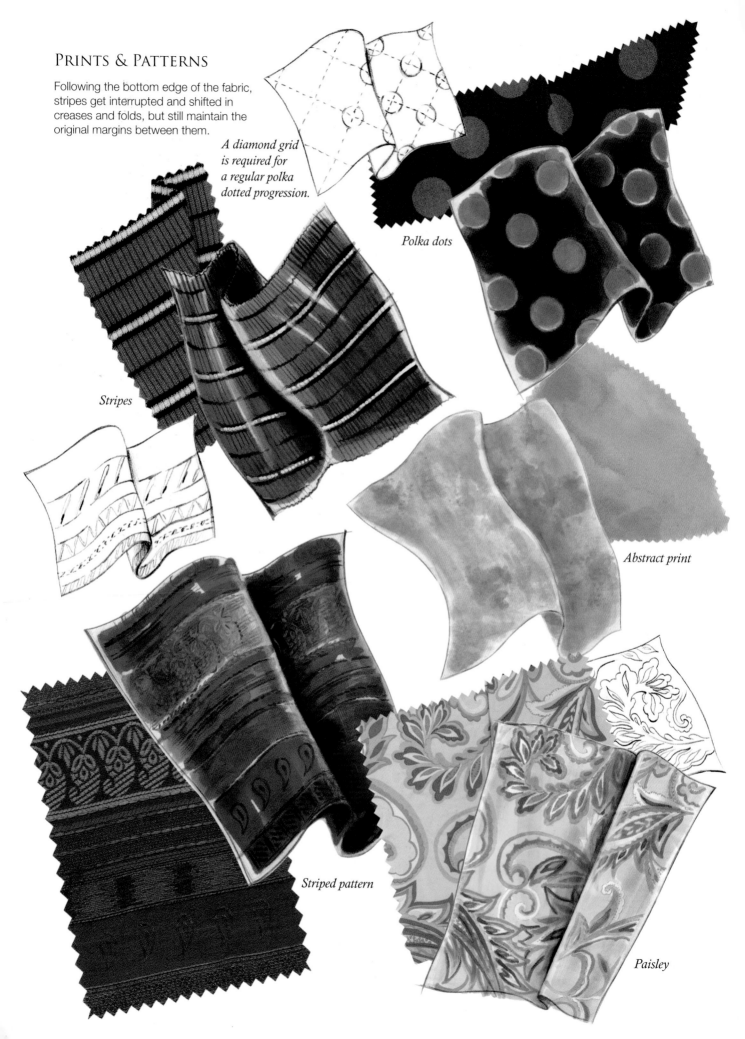

PRINTS & PATTERNS

Following the bottom edge of the fabric, stripes get interrupted and shifted in creases and folds, but still maintain the original margins between them.

A diamond grid is required for a regular polka dotted progression.

Polka dots

Stripes

Abstract print

Striped pattern

Paisley

Each type of
print or pattern
requires a
specific approach
and technique.

A precise
preliminary
drawing is
needed for
detailed prints
like paisleys
and florals.

*Stylized floral
print*

Stylized animal print

*Quick sketch
of printed
fabrics.*

Some stylized
and abstract
prints can
be rendered
as an artistic
impression of
the fabric.

FLORAL MOTIFS

To capture the feeling of a print, colours should be identified and matched closely. This applies to the scale and proportions of the design elements as well.

Rendering flowers

Dark background print

Adding dark background

Light background print

Prints look cleaner when the motif is sketched and coloured first with the background carefully filled in afterwards. A colour chart of all the colours being used in a print is very helpful in achieving a realistic illustration.

Colour charts help identify the number of colours used in a print.

When illustrated on a figure, prints should be scaled down accordingly.

Partial rendering

Use a diamond grid for repeats following the flow of the fabric.

Folds in a fabric shift and distort the pattern.

EXPLORING MEDIA

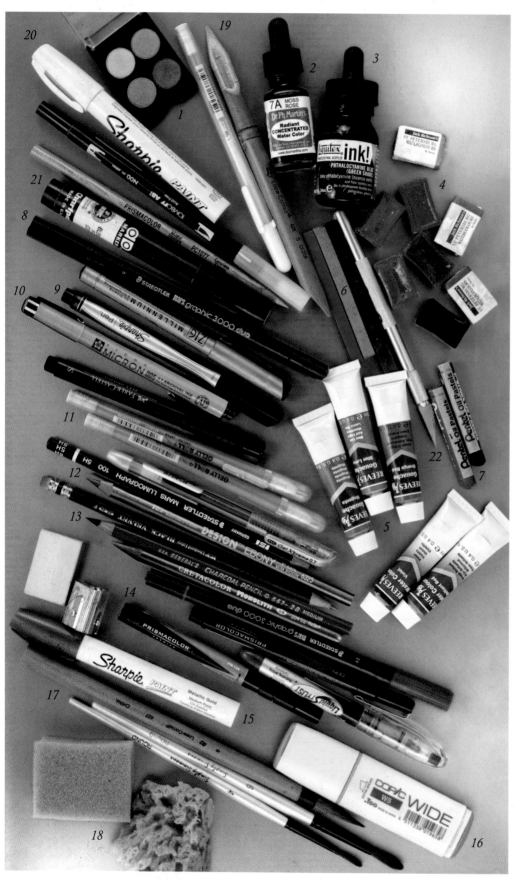

1. Eye shadow

2. Watercolour dye

3. Coloured ink

4. Watercolour

5. Gouache

6. Pastel

7. Oil pastel

8. Brush pen

9. Sharpie pen

10. Micron pen

11. Gelly Roll pen

12. Design ebony

13. Charcoal pencil

14. Gold pen

15. Gold paint marker

16. Copic wide marker

17. Paint brushes

18. Sponges

19. Bamboo reed pen

20. White paint marker

21. Blenders

22. X-Acto knife

INK

A large spectrum of supplies and materials are available to enhance a variety of illustration techniques and styles. Coloured media is exciting and expressive, but most artwork begins with a pencil or ink line drawing.

Ink is spontaneous and perfect for linear or dimensional wash illustrations. India ink applied to paper with a brush, reed pen, or a fine point nib can create an unpredictable variety of lines. Loose, spiky, broken, bold, faded, and irregular lines merge into an energetic drawing. This is called "line quality."

Sputtering and dripping ink, scratching the paper surface with a dry brush, or bleeding and stamping–all of these effects will create an accidental and often magical drawing.

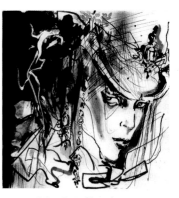

Metal tip / brush pens

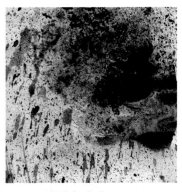

Ink / salt & water

Ink / dry brush

Quill / bamboo stick

PENCIL

Line drawing is pure, simple, and expressive. Graphite, charcoal, or china markers are appropriate for quick and loose line drawing. When detailed work is needed, classic HB pencils are preferred for their fine, flexible lines. To achieve dramatic line quality, apply varying pressure and hand movements.

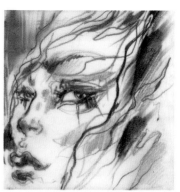

Line density and modulation

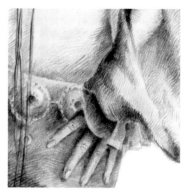

Cross-hatching

Pressure and movement

Blended gradation

Cross-hatching and smudging are ideal for shading, which can vary from soft to intense. Erasers can be used to create highlights when gently applied over shaded areas.

Anna Kiper

COLOURED PENCILS

Coloured pencils mixed
with other media or
used by themselves
can create spectacular
textures. The wide range
of line qualities can
be used to gradually
add layers of depth,
dimension, and a variety
of surfaces.

Pencils can be applied over tinted or coloured papers for a partial, looser rendering effect that exposes the background colour. Often the background is used as the model's skin-tone.

Eye make-up

Dry brush

Pastel

Pastels and paints applied with a dry brush, and even eye make-up, will blend organically with coloured pencils on craft paper.

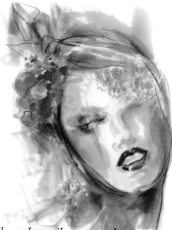

Coloured pencils over markers

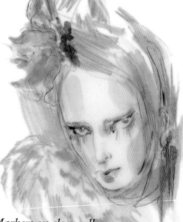

Markers on clear vellum

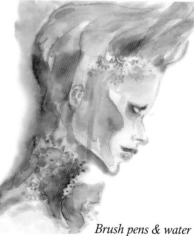

Brush pens & water

Pen outline

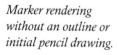

Marker rendering without an outline or initial pencil drawing.

Markers come in a variety of brands and colours. More shades can be obtained by layering and blending. A variety of tips, sometimes up to three in one marker—from fine point to wide wedge and brush—will allow an artist to create a spectrum of lines and strokes.

Compared to ink, gouache, and pencils, markers are a smooth and vibrant media. Markers work best on specifically designed marker paper. Unusual experimental effects are achieved when they are used on translucent or rough surfaces. When applied evenly in layers, markers can look as flat and opaque as gouache. When applied partially from the back and front of paper, and blended with a special blender marker or alcohol, markers can imitate the transparency of watercolour.

Anna Kiper

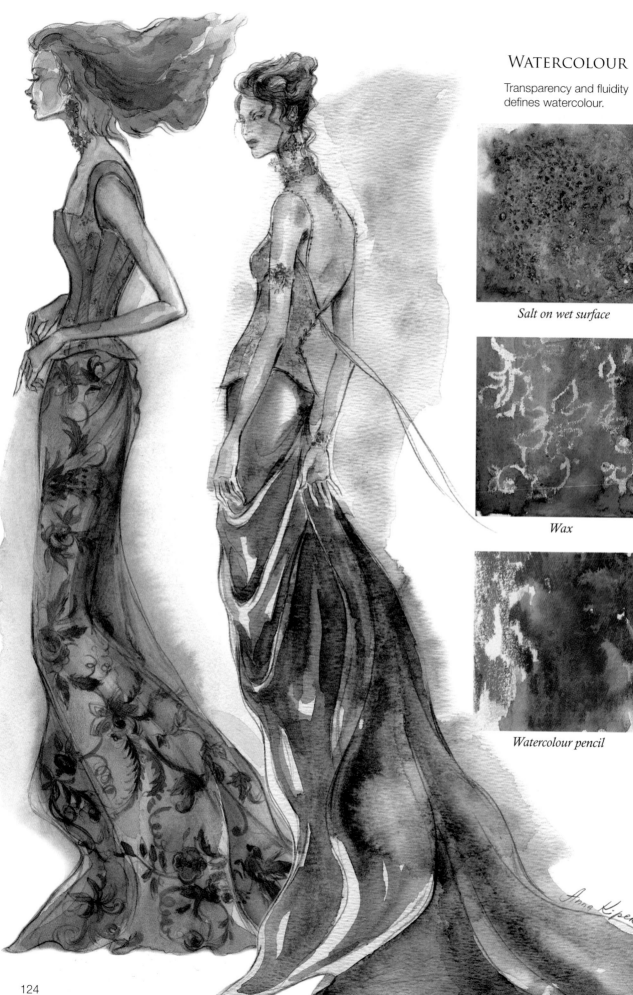

WATERCOLOUR

Transparency and fluidity
defines watercolour.

Salt on wet surface

Wax

Watercolour pencil

Anna Kiper

124

When generously diluted with water, paint can be applied on a wet or dry textural surface with different brushes. When applied on a wet surface, watercolours will bleed beyond the outlines of a drawing, creating an ephemeral effect. Avoid dry, forced strokes and multiple layers to keep the paint fresh and translucent. The look of the stroke and stain will depend on the texture of the watercolour paper.

Salt generously applied over wet paint will create a grainy texture. Shake off the excess salt when the area is totally dry. Wax can be applied on paper before water or paint is used. Paint will avoid the waxed area revealing it white. Soluble pencils perform as watercolour when smeared with a wet brush.

GOUACHE

Gouache is a flexible and practical water-based paint. It can look translucent when generously diluted with water and thickly textured when applied with a dry brush. Naturally opaque and flat, gouache works well on smooth vellum or textural craft papers.

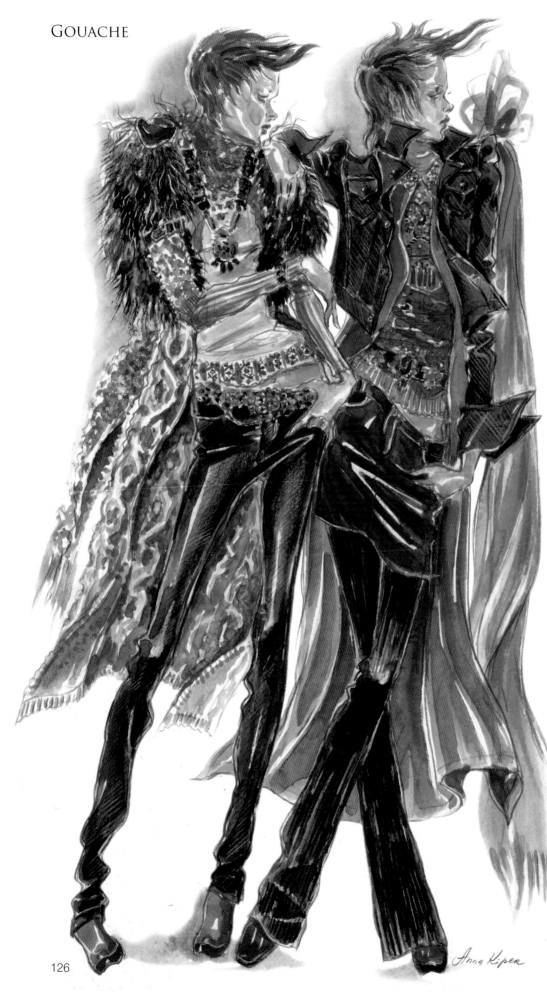

Leather

Denim

Fur

Cable knit

Corduroy

Anna Kiper

Gauze

Sea sponge

Foam sponge

Dry brush

Steel wool

When gouache is mixed and diluted, any colour can be achieved. This makes it possible to imitate any fabric or texture. Light saturated colours will look bright and vibrant when applied over dark surfaces. This effect cannot be achieved with watercolours or markers. A variety of textures can be created with sponges and brushes.

COLLAGE

Collage is spontaneous, abstract, and freeform. However, collage techniques can be mixed with traditional illustration styles, substituting detailed print rendering with simple paper cutouts.

X-Acto knife

A copy of a drawing can be applied over a printout of a fabric. Use the drawing as a guide to cut the exact silhoutte from the print, removing all creases and seam lines. Then apply glue and paste the printed cut-out to the original drawing.

A variety of stylish and expressive collages occasionally highlight the editorial pages of fashion magazines. The use of colour and handmade craft paper, magazine cutouts, fabrics, skins, and furs, can create dimensional, rich, and vibrant artwork. Unusual materials including masking tape, nature elements, and even food will create an avant-garde, rebellious statement and bring fashion illustration to the level of fine art.

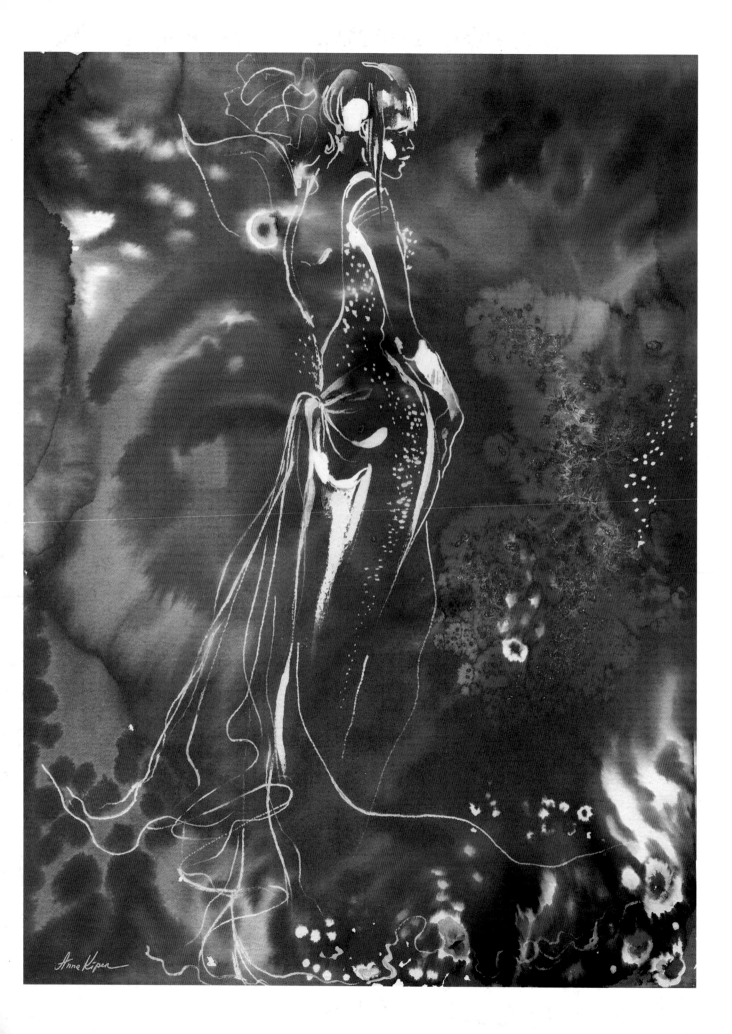

NOVELTY TECHNIQUES

The surreal vibrant atmosphere of the image on the opposite page was created by dropping watercolour dyes on a wet surface. Sea salt was sprinkled over the paint to achieve textural variation. The silhouette was drawn over the dry surface with a reed pen and cotton buds (Q-tips) dipped in bleach.

The same design and silhouette is magically transformed into a collage: a linear ink drawing, printed in a few colours on clear acetate, is layered over a coloured paper collage.

Anna Kiper

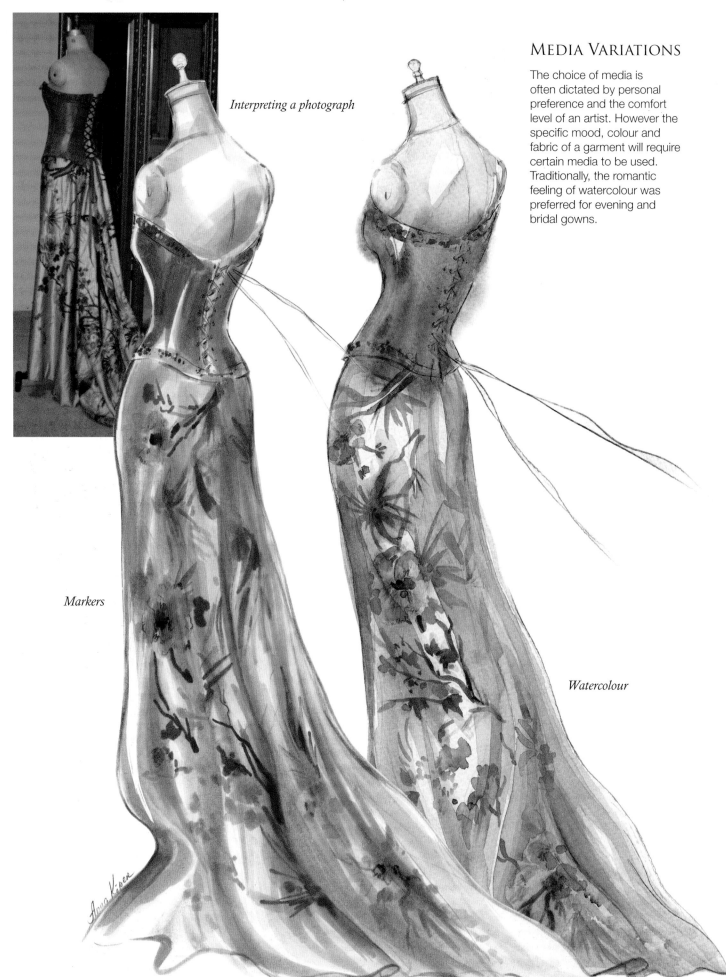

MEDIA VARIATIONS

The choice of media is often dictated by personal preference and the comfort level of an artist. However the specific mood, colour and fabric of a garment will require certain media to be used. Traditionally, the romantic feeling of watercolour was preferred for evening and bridal gowns.

Interpreting a photograph

Markers

Watercolour

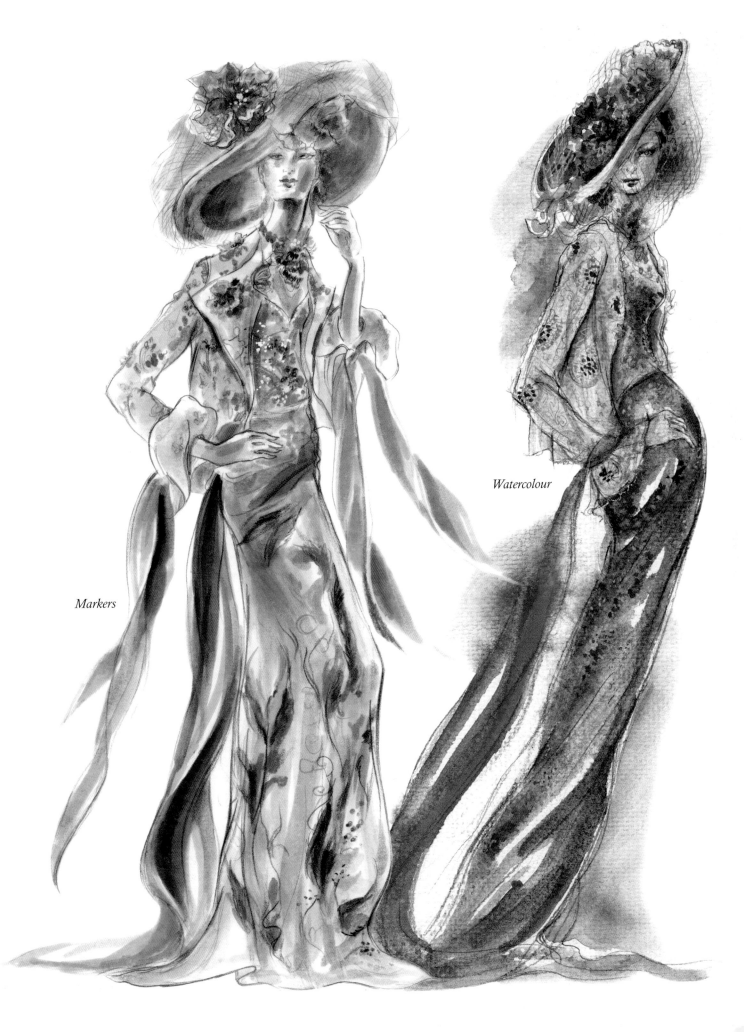

Markers

Watercolour

MODEL DRAWING

PENCIL

Relax and observe the live model. With time and experience, learn to trust your subconscious choices in media and composition.

Lines smeared with eraser

White out for accents

Suggestive print & texture

For brief, spontaneous drawings keep your eyes on the model at all times letting energetic quick lines flow. Textures, prints, and details are simplified and sketchy. The ultimate goal is to capture the moment.

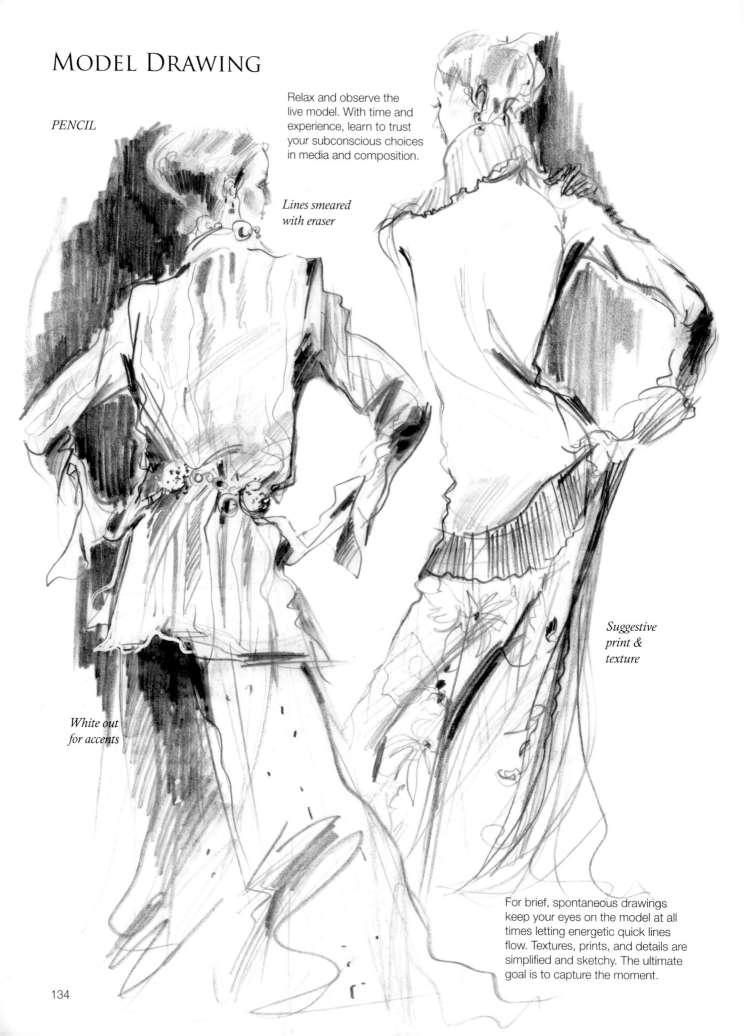

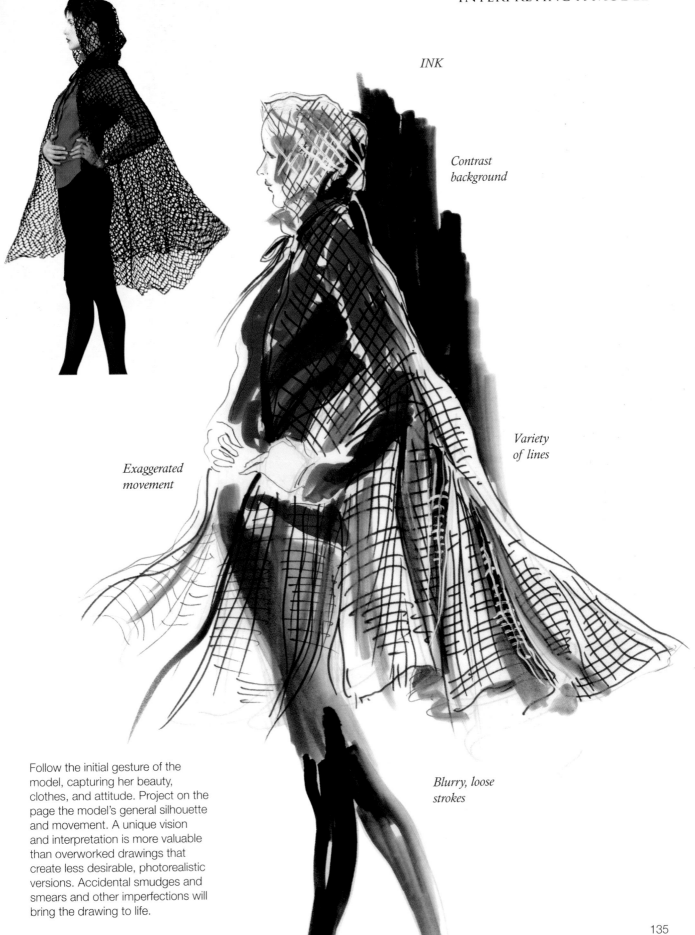

INK

*Contrast
background*

*Variety
of lines*

*Exaggerated
movement*

*Blurry, loose
strokes*

Follow the initial gesture of the
model, capturing her beauty,
clothes, and attitude. Project on the
page the model's general silhouette
and movement. A unique vision
and interpretation is more valuable
than overworked drawings that
create less desirable, photorealistic
versions. Accidental smudges and
smears and other imperfections will
bring the drawing to life.

FOCAL POINT

Focus on what's important, giving just enough information to convey the attitude of the model.

WATERCOLOUR

Clothes captured with spontaneous energy often draw more attention then the refined facial features of a model.

Watercolour pencil

Salt & white out

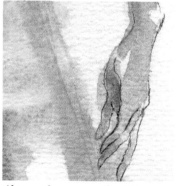

Absence & presence of outline

The pink fur, in this example, is the focal point of the image. However, the contrast of the detailed hand drawing next to a washed-out, blurry silhouette of a skirt also grabs the viewer's attention and balances the composition.

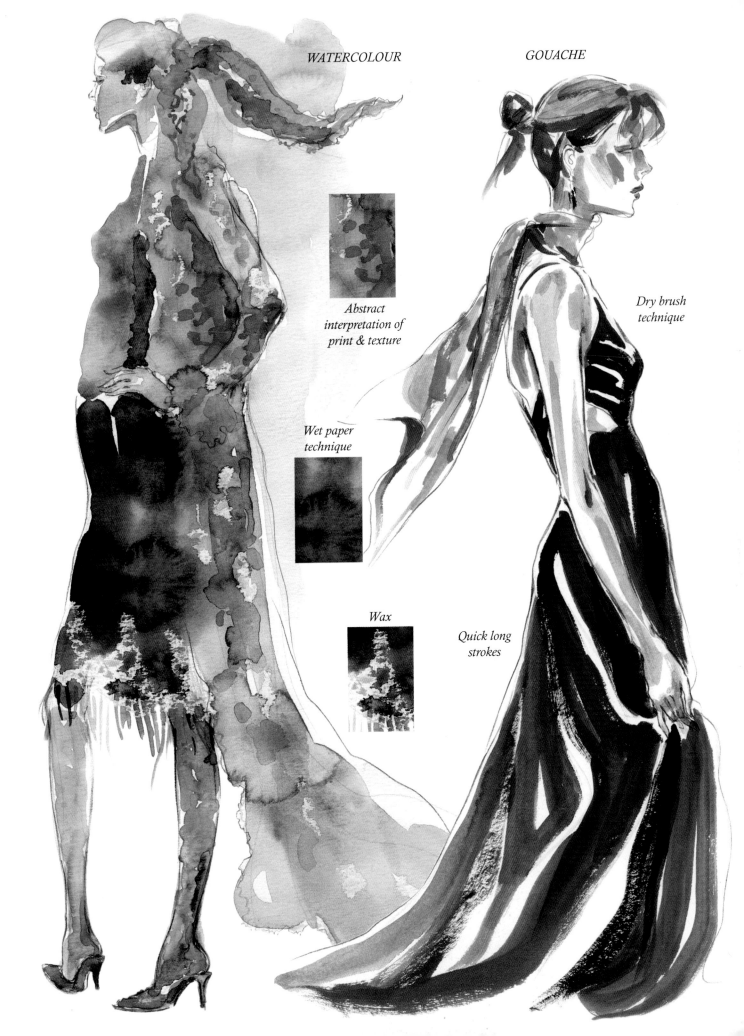

WATERCOLOUR

GOUACHE

Abstract
interpretation of
print & texture

Dry brush
technique

Wet paper
technique

Wax

Quick long
strokes

BARE MINIMUM

Even a brief simplified sketch can be done in steps. This page shows how a spontaneous marker blocked drawing is created in stages.

1. Quickly block a silhouette with a light coloured marker.

3. A partial pencil outline and texture completes the drawing.

2. Base colours are briefly applied and layered creating dimension.

To capture quick
impressions of
textures, short
cuts such as simple
rubbing techniques
can be used along
with energetic
marker and
pencil lines.

*Brush pen
speckles*

*Sand paper
rubbing*

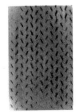

*Horse hair
tape rubbing*

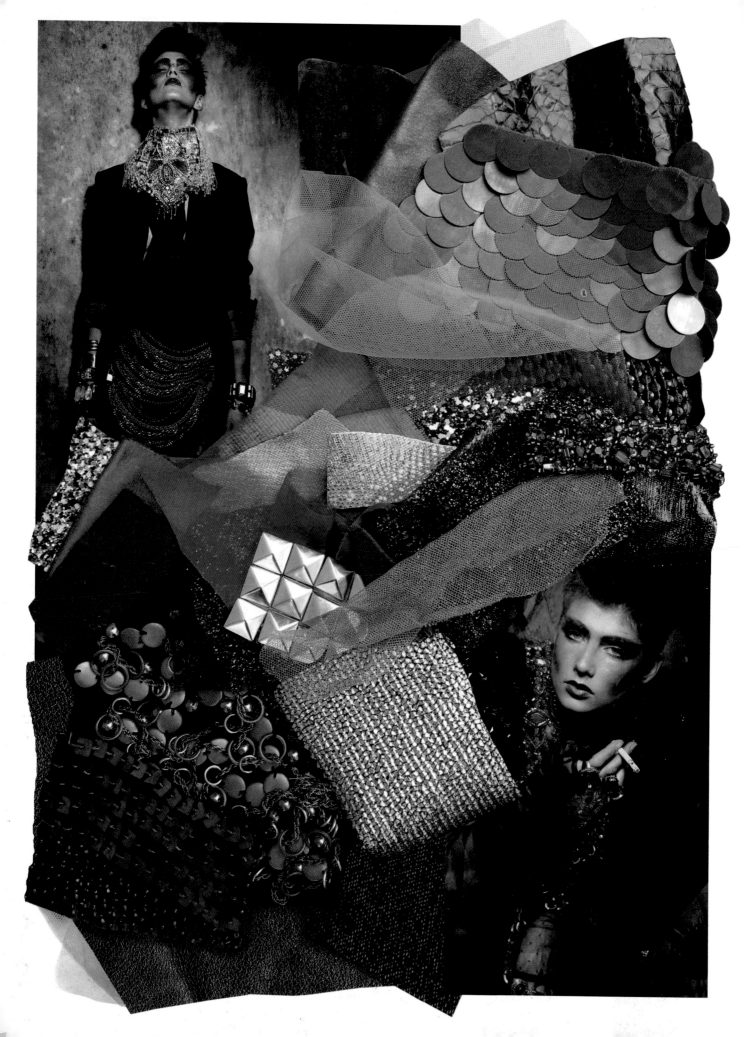

INSPIRATION. MOOD. DESIGN

A design journal is an essential tool for the development of a fashion collection. Fabrics, trims, and inspirational images help create an atmosphere for the creative process to begin.

Rough sketches of accessories and beauty, along with detailed thumbnails, can shape the design vision for a future collection.

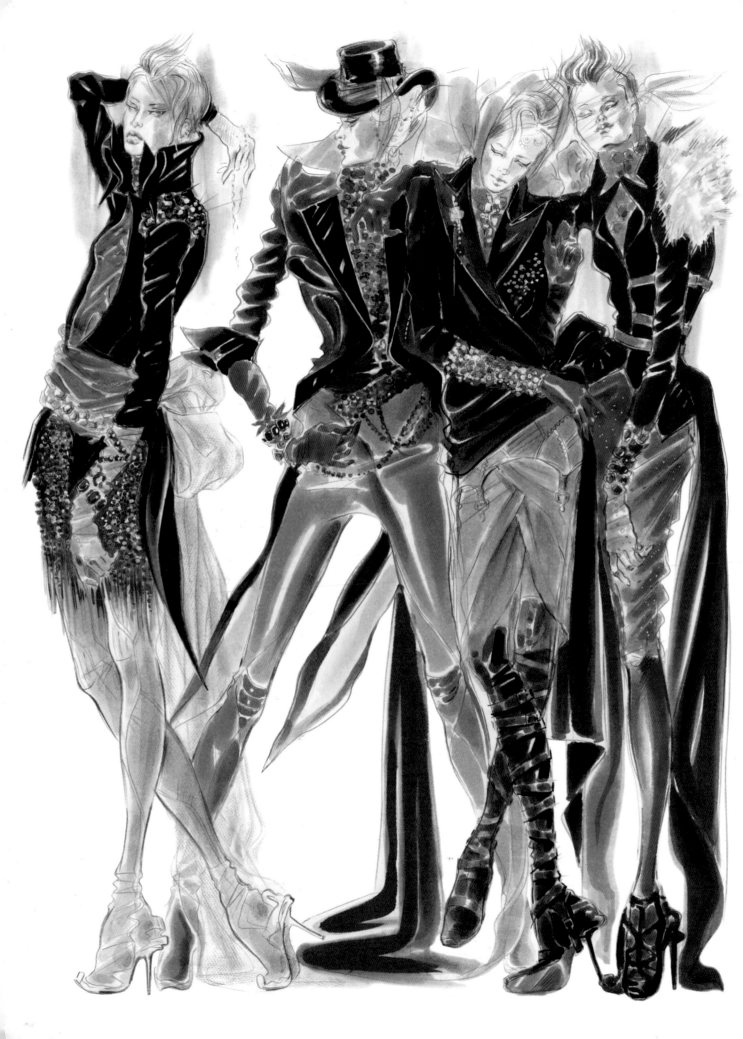

A DESIGN COLLECTION

Initial inspirational material and
design references can help
visualize the concept behind a
design collection, but do not need
to be followed exactly. In the final
presentation, all of the elements
come together—colour and fabric
sensibility, layout and composition,
styling, and attitude—to editorialize
the designer's aesthetic vision.

ACKNOWLEDGMENTS

PHOTOGRAPHERS:
David White – model photography
14,135,140-1
Rick Shifman – fabric collage 140,
author's portrait
Anatoly Shifman – fabrics and
supplies 93,102-3,116

MODEL STYLIST:
Cynthia Altoriso 14, 140-1

PHOTO MODEL:
Fay Leshner

DRAWING MODELS:
Shaunna Gray
Jacintha Morvan
Constance Small
Michele Stewart
Ignacio Villeta

GRAPHIC DESIGNER:
Valeriya Miller

TEXT EDITOR:
Janet Chung

CONSULTANT:
Felicia Da Costa

DESIGN
CREDITS:
Peter Mui "YellowMan" 76, 98
Maggie Norris – outfits
14,132,140
Adria de Haume – brooch 64
Anna Kiper for Maggie Norris
124-5
Fay Leshner – gold necklace,
black blouse, makeup – 140-1

DESIGNS ILLUSTRATED:
John Galliano 2
Jean Paul Gaultier 108, 122-3,
144
Emanuel Ungaro 133
Tracy Feith 127

Thanks to B&J and Mood fabrics.

Thanks to all FIT and Parsons
colleagues for believing in me.

Thank you to everyone at D&C,
especially James Woollam and
Freya Dangerfield.

Most special thanks to my husband,
Rick Shifman, for his enormous help
and support. This book would not
have been possible without him.

To anyone who has been left out
in error, my sincere apologies and
thank you.

144

INDEX

Anna Kiper